THE INVISIBLES

First published in the United States of America in 2014 by
Rizzoli International Publications, Inc.
300 Park Avenue South
New York, NY 10010
www.rizzoliusa.com

Originally published in French as *Les Invisibles* in 2013 by
Éditions Hoëbeke

© 2013 Éditions Hoëbeke, Paris

Design: Isabelle Chemin
Color reproduction: Fotimprim

2014 2015 2016 2017 / 10 9 8 7 6 5 4 3 2 1

ISBN: 978-0-8478-4306-0

Library of Congress Control Number: 2013958113

Printed in Spain

SEBASTIEN LIFSHITZ

THE INVISIBLES

Vintage Portraits of Love and Pride

RIZZOLI
NEW YORK

New York Paris London Milan

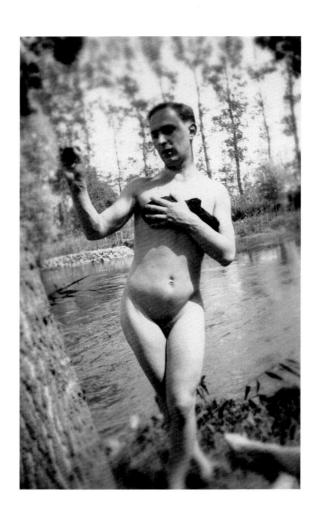

When I began working on *The Invisibles*, I first had to convince a producer to come along with me on this adventure. The only elements I had at the time were a hypothesis and a collection of amateur photographs I had been putting together for many years. These images immediately charmed Bruno Nahon, a producer at Zadig Films. For him, they embodied every discourse I could have presented on the subject. He said yes right away, without seeing a single line written by me.

So everything started from there. One day, I was walking through the Vanves flea market, searching for unique images, as is my habit. Ever since I was a teenager, I've spent my time hunting through flea markets and lawn sales. I came upon a family photo album belonging to two old ladies. They were Kodachromes from the 1960s. The images weren't extraordinary in any way, but I was very quickly drawn to a detail. I was unable to discern the nature of the relationship between these two women: were they two sisters, two friends, or two lovers? I asked the dealer if he had other albums, and miraculously, he pulled out ten others that were vegetating in old boxes. I bought them all and returned home to begin a kind of investigation inside the albums. Very quickly, I understood that these two women were a couple. Many of the images showed them intertwined, hand in hand, loving eyes. What astonished me was that their middle-class appearance didn't match the act: the act of producing an image of homosexual love at a time when discretion was the norm. Because to obtain these images, they had to have gone to a small neighborhood photo lab to develop the film and then go back to pick up the prints. They, therefore, had to run the risk of exposing themselves socially. The need to keep a memory of their love was certainly stronger than the disapproval of some business or any concerns about what others might say. Later, I found many other anonymous images with traces of intimate homosexuality. Every time, there were the same testimonies of freedom and happiness. With each discovery, I was stunned, for these images didn't match the official history of homosexuality as it had been conveyed to us. As a teenager, when I dreamed of my adult life, if I stuck to the literature or the few films that existed on the subject, the future promised to be dark. To be gay or lesbian meant belonging to a genealogy of suffering, to have a dramatic, if not a tragic, destiny. Despite the many battles and certain victories that ensued, the homosexual remained a victim

in the collective consciousness; a hidden man. Yet these images, which I had found through the years, were telling another story, one about a homosexuality without inhibitions, gentle and playful. It's always dangerous to generalize, but looking at these documents, I began to form a hypothesis: what if a majority of homosexuals from these different periods had, for the most part, succeeded in living a good life, despite who they were? Perhaps they were able to negotiate something with the family, their professional milieu, or society as a whole; discretion nevertheless remaining the rule when it came to their love life. Sadly, I couldn't make these images talk, so the best way to respond to my hypothesis was to seek out men and women between the ages of sixty and ninety and to ask them what it was like for them.

I looked at these photographs a lot and very quickly realized that they contained something original. They allowed me to be able to associate homosexuality with lives that appeared to be like all other lives: happy at times, free and lighthearted. I noticed that each era produced motifs, attitudes, and subjects that belonged to their times. Before the war, cross-dressing and role-playing were particularly frequent, as countless amateur images from the 1920s show. People liked provocation and liked to play with ambiguous situations. Was this the influence of the social freedoms of the interwar period, when an appetite for celebration and a revolutionary spirit reigned? Dada and Surrealism are always nearby. You think of Marcel Duchamp's portrait as Rrose Sélvay, of Man Ray's photographs of the famous cross-dresser Barbette and also Brassaï's of the homosexual balls of *gai* Paris. These images have become the insolent icons of the *années folles*. In these photographs, like a mirror, you find the same penchant for the burlesque and the strange, masked faces, twin couples and fairy queens. In the 1940s, the party had clearly ended and all those scenes became rarer. The world had changed. The war had passed through. A new population needed to be born and society had to be rebuilt around traditional—even reactionary—values. Amateurs invented other scenes that certainly conformed more to the morality of the time. Gradually, new consumer goods invaded the amateur image: refrigerators, televisions, gleaming cars, and Formica furniture were the new heroes. It wasn't until the mid-1960s that the taste for the outrageous and rebellious returned.

I never wanted to limit my research to photographs in which homosexuality was certain. On the contrary, I extended my investigations to every form of its

representation. In the selections that I've made for this book, I preferred to combine all these levels of evocation to allow for a freer interpretation of each one. First there are those in which homosexuality is apparent, those in which it is highly probable, and all those where the people photographed "played at." I'm thinking, for example, of the ones of the *garçonnes*, who to me so perfectly embody the battle women waged over the last century to gain their independence and win equal rights. By donning masculine attributes, sometimes to the point of caricature, they are politicizing their bodies and the images that go with them. These photographs are like manifestos thrown into the "oppressors'" faces. Cigarette in mouth, alcohol in hand, an impeccable suit and tie: it all belongs to a theatricality that asserts a taking of power and aims to be indelible.

These images are not only documents. I also chose them for their visual beauty. In most cases, there were no captions written on the back. That's why I preferred to reproduce them that way in the book. No chapters, no text. Without ever conditioning the way we look at them. Like a succession of images that questions us about the status of masculine/feminine, about homosexual desire, and also about identity in general.

While filming *The Invisibles*, I often thought of these photos. What was striking at times was that I had the feeling of having met the people who were in these images but sixty years later. The accounts that I was filming could have very well been about one of them. They were their unsettling expression. I was under the strange impression of connecting the past with the present. Of being in the continuity of history. And so I was able to partially verify my hypothesis: despite the difficulties, happiness did exist in the life of these homosexual men and women and continues still to run through their veins.

—S. L.

Translated from French by Molly Stevens

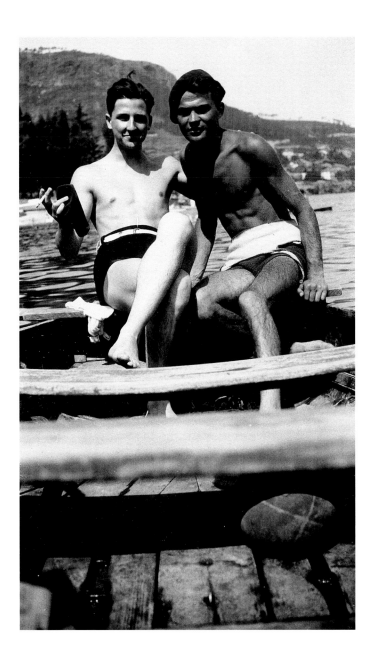

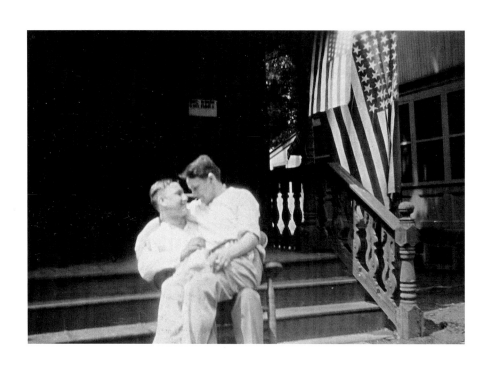

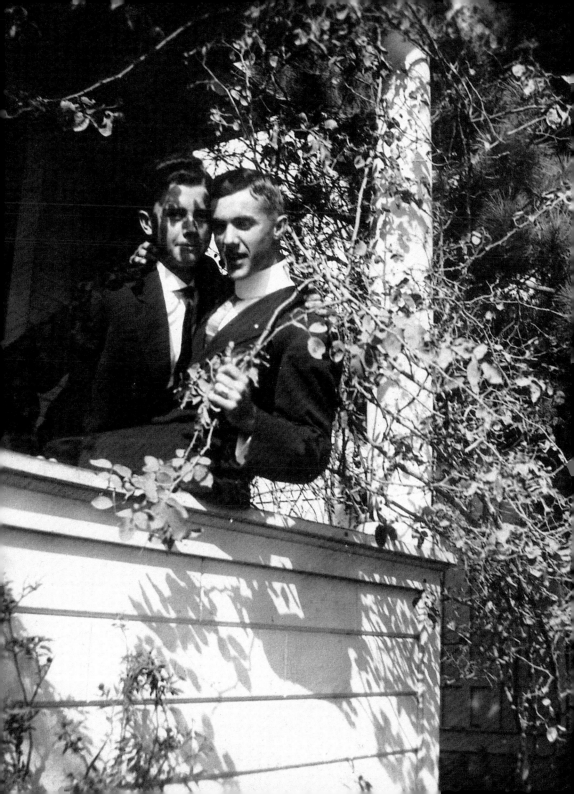

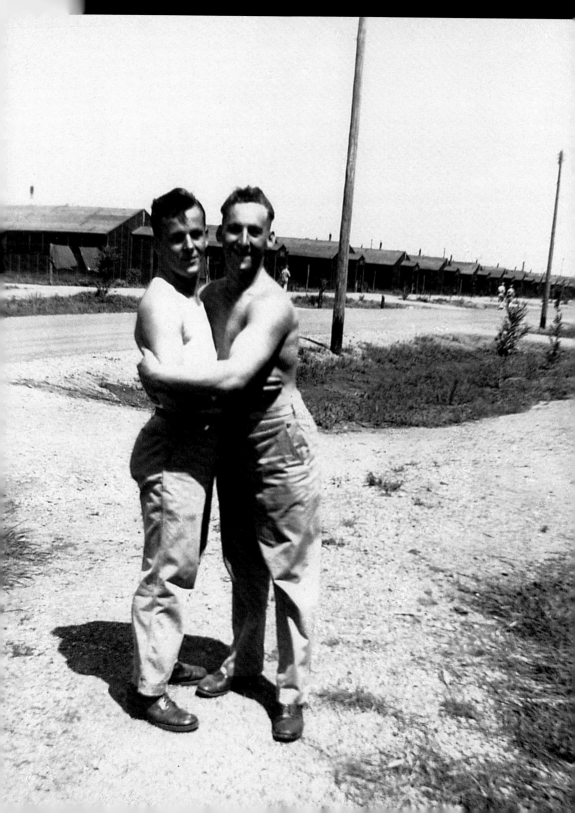

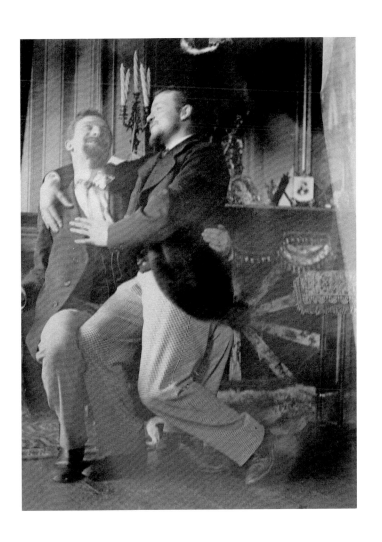

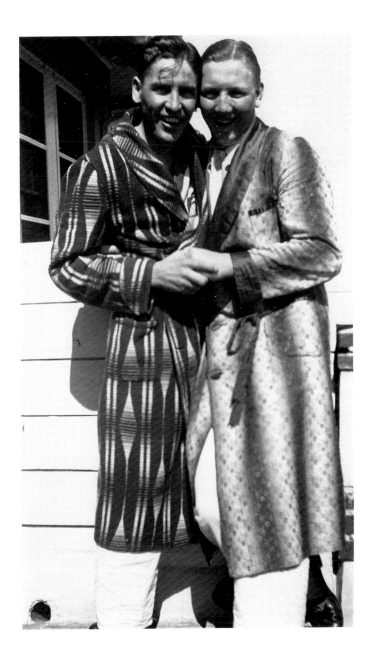

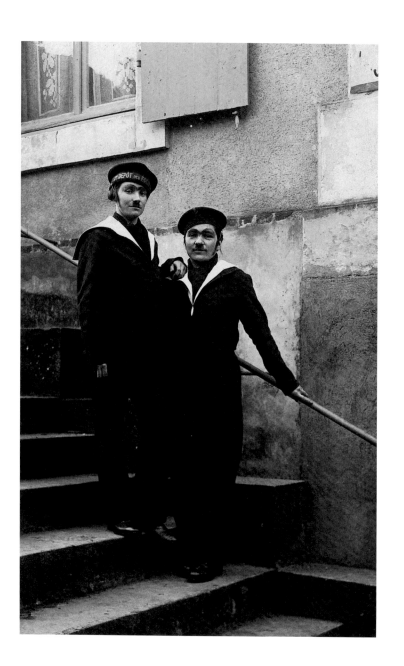

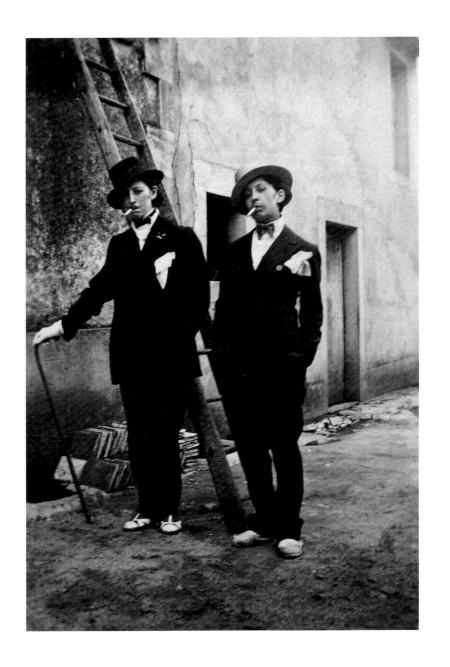

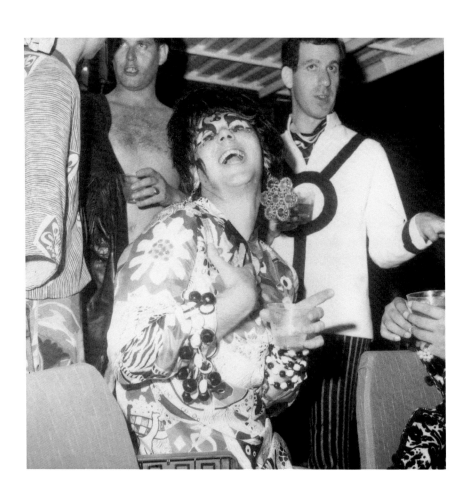

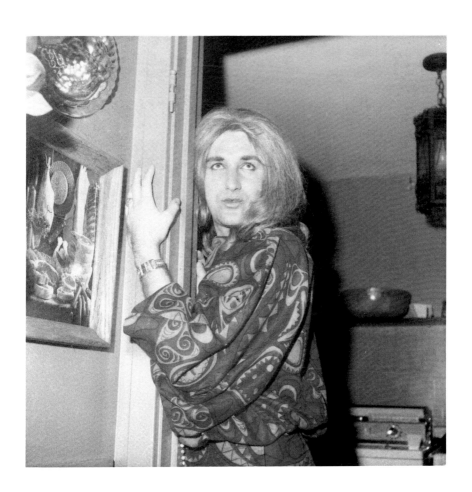

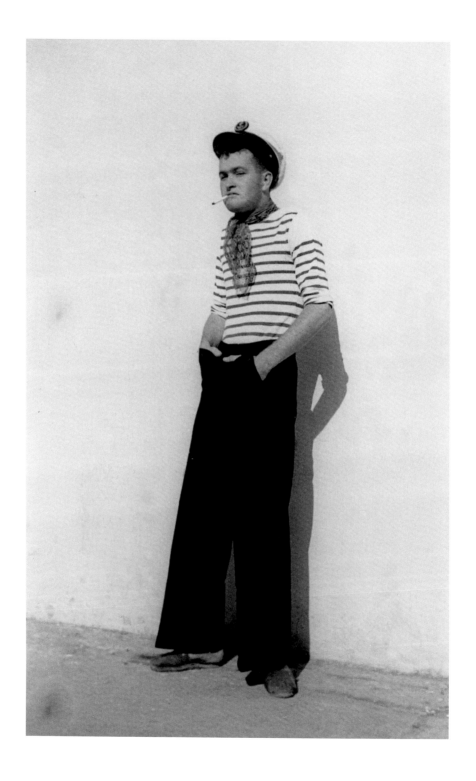

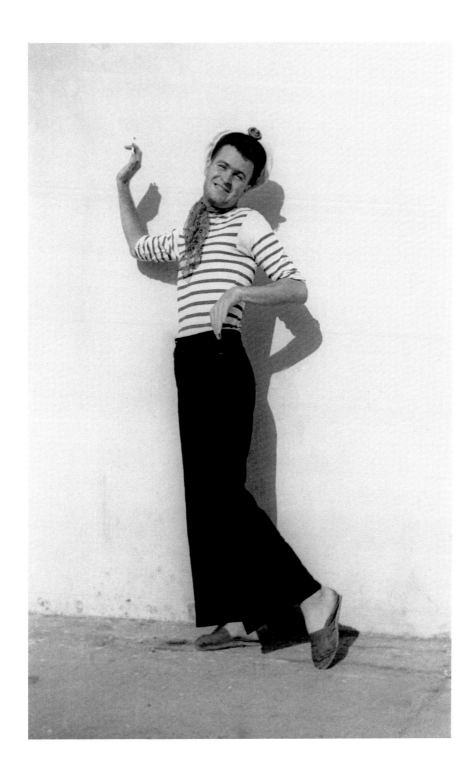

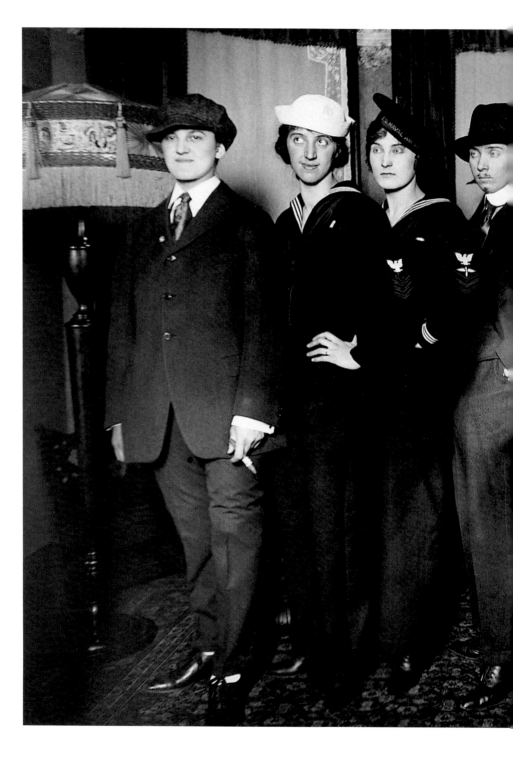

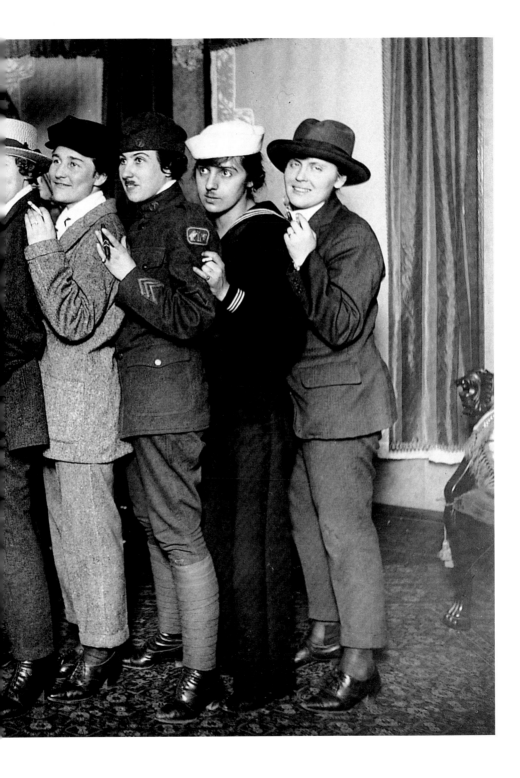

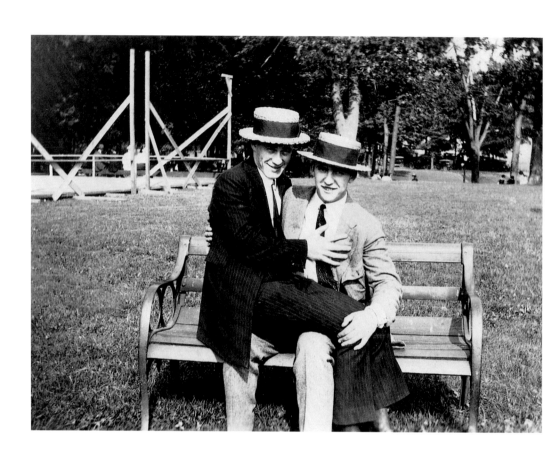

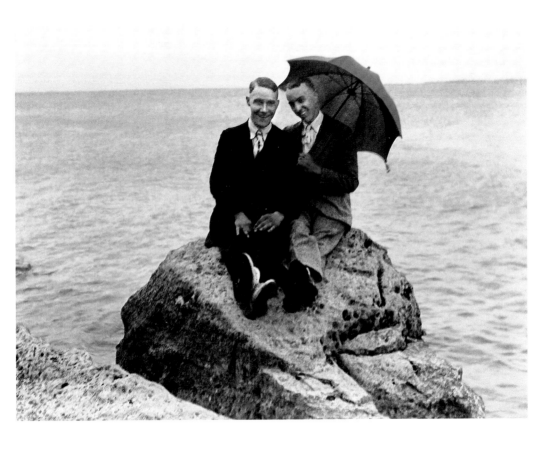

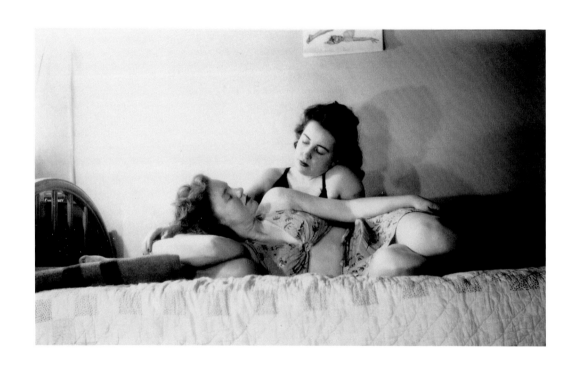

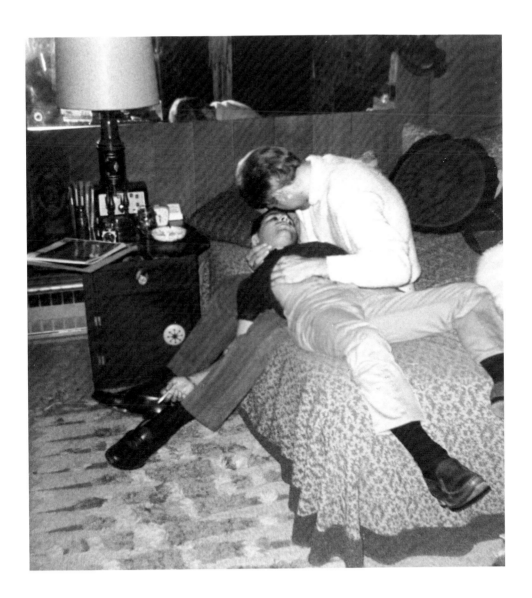

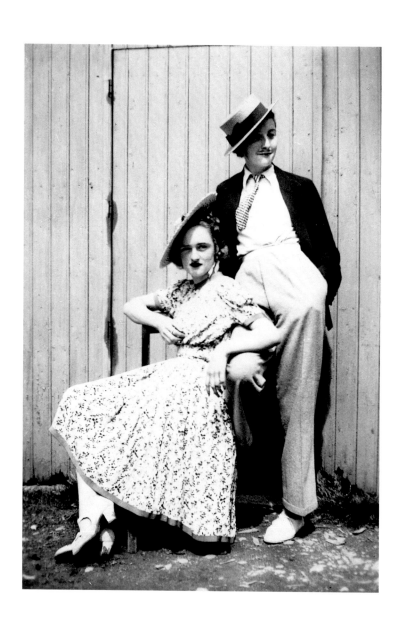

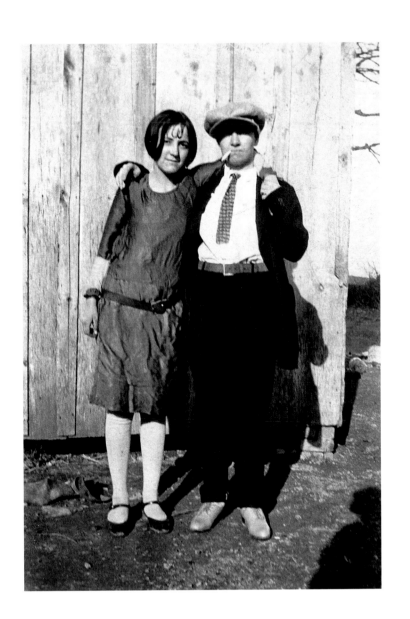

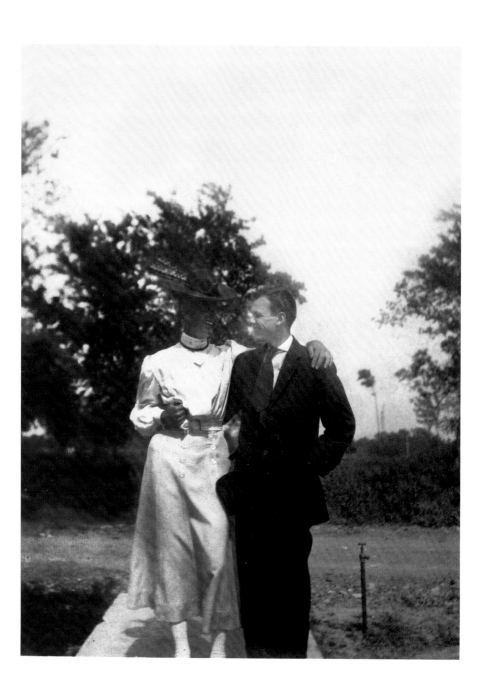

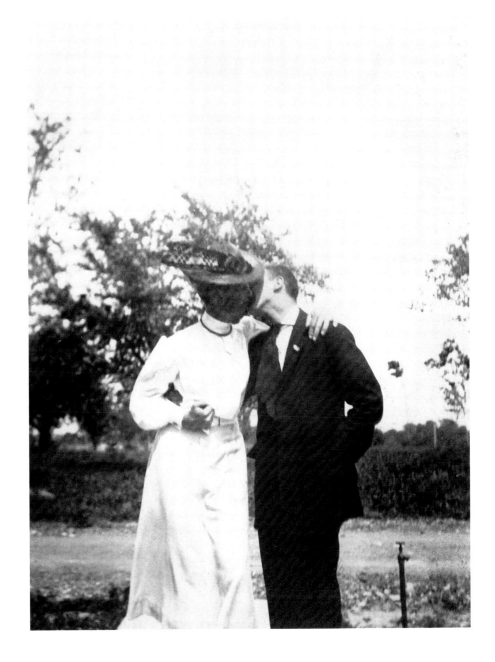

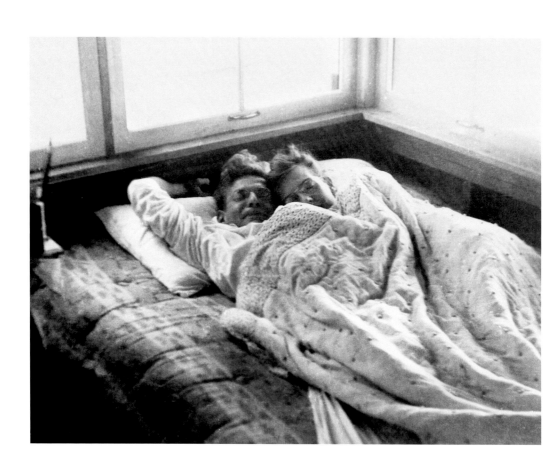

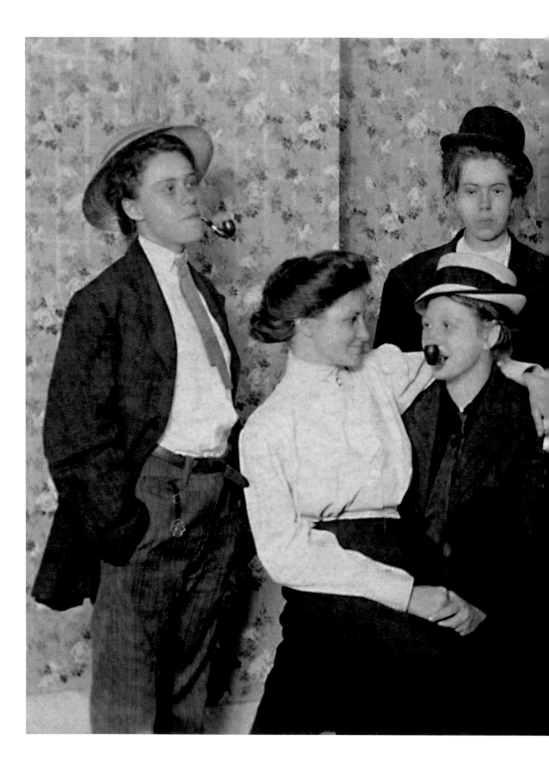

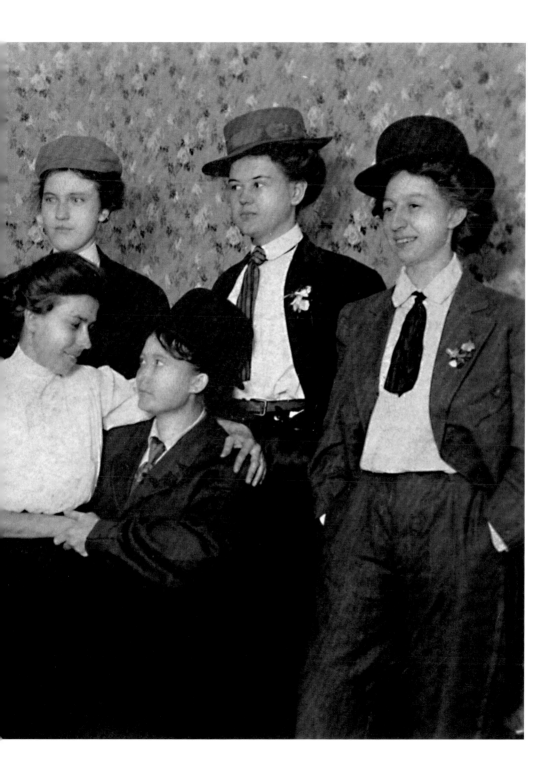

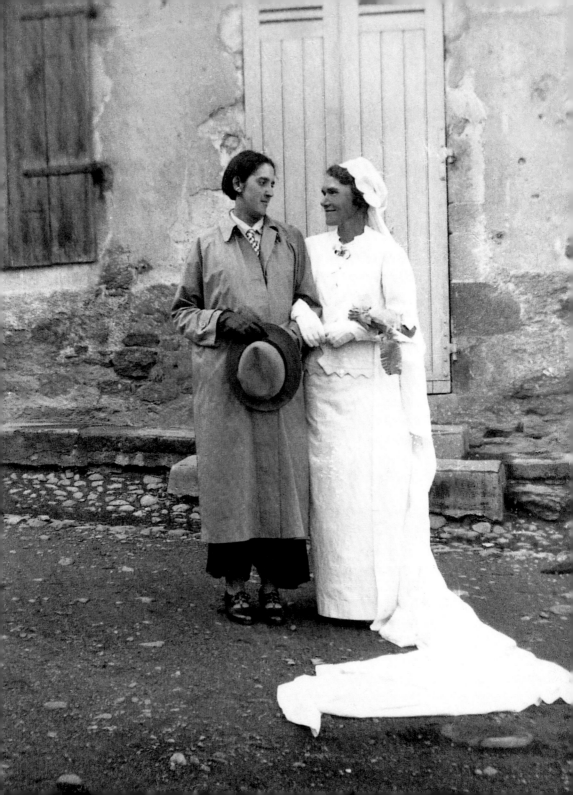

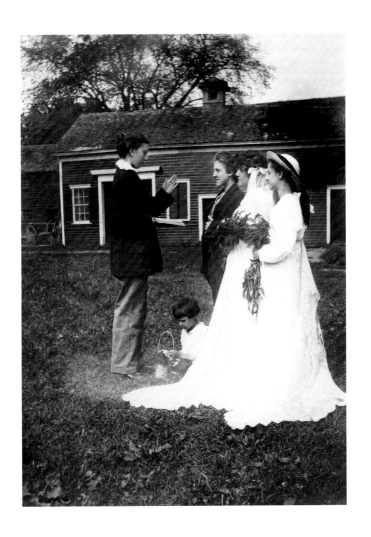

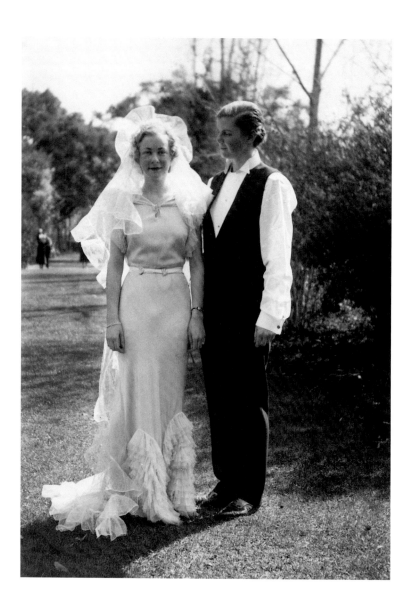

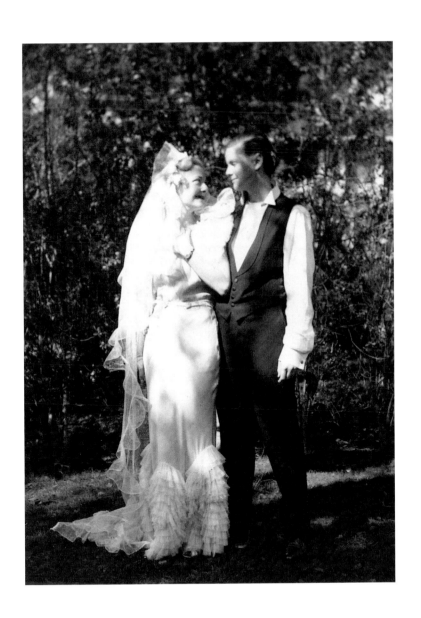

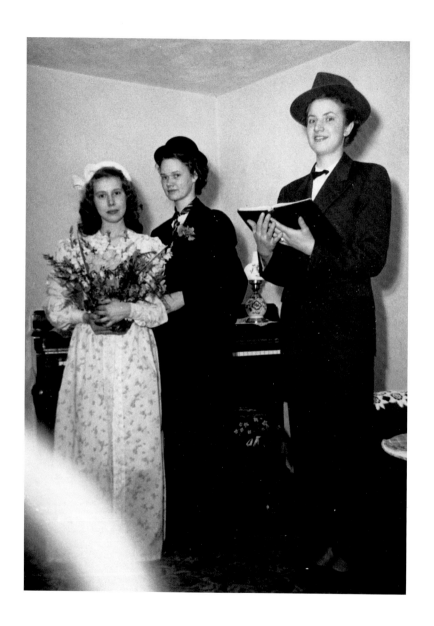

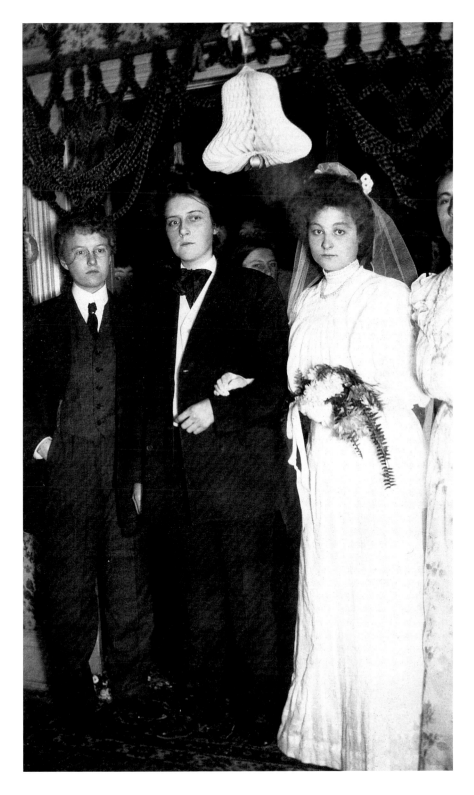

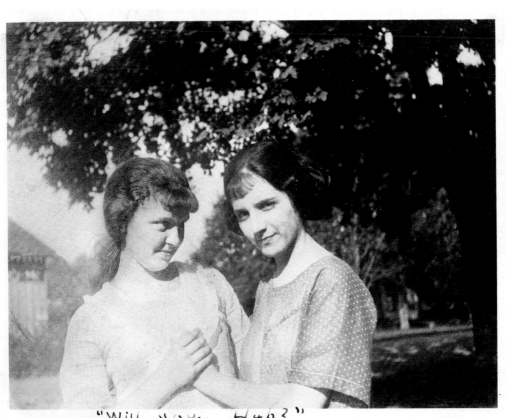

"Will you, Huh?"

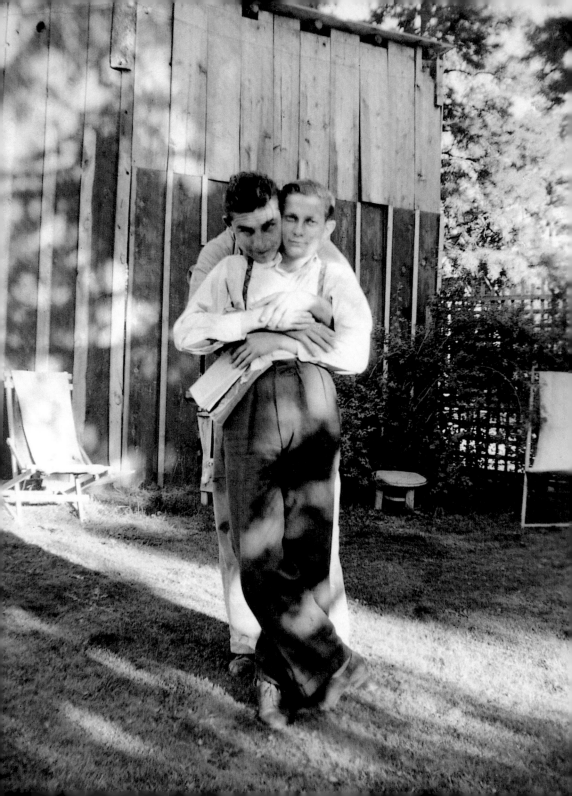

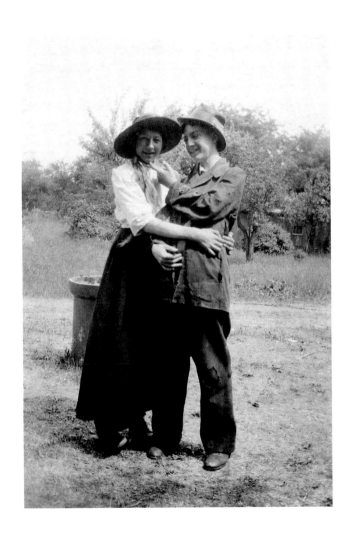

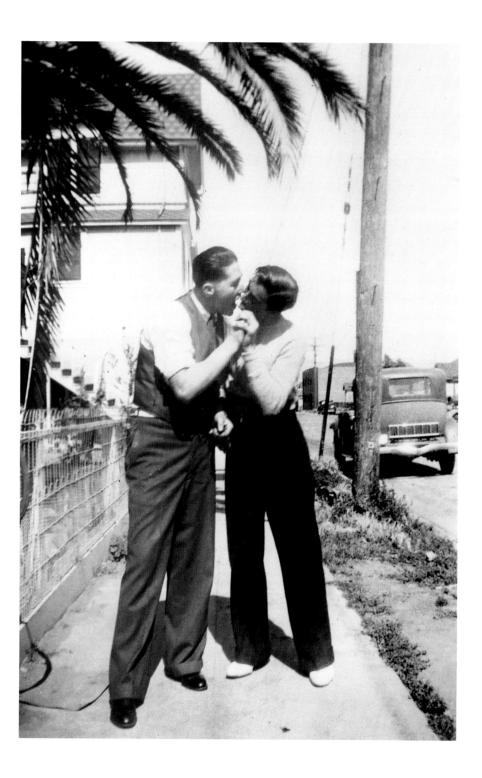

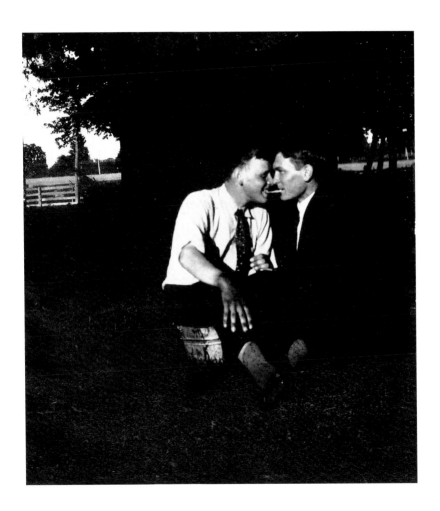

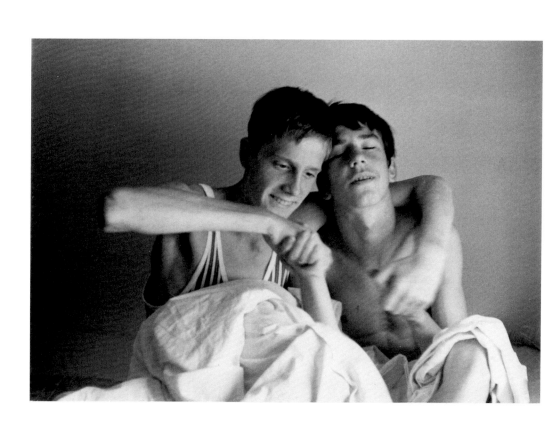

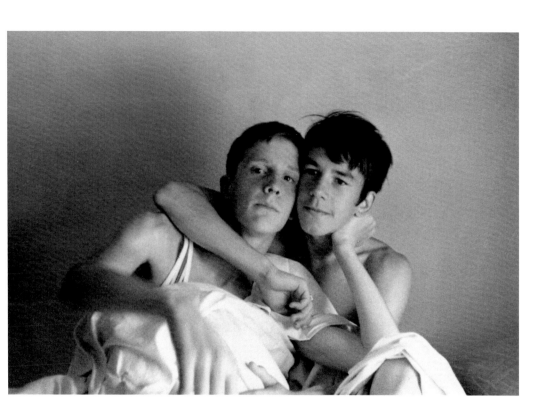

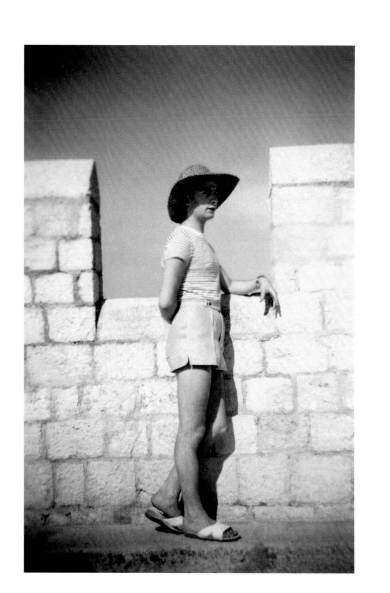

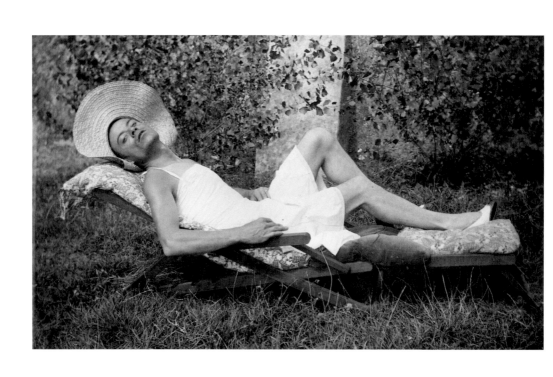

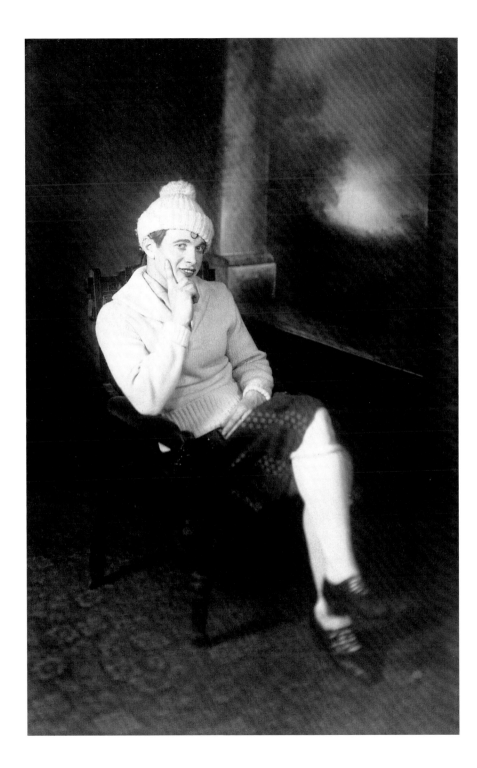

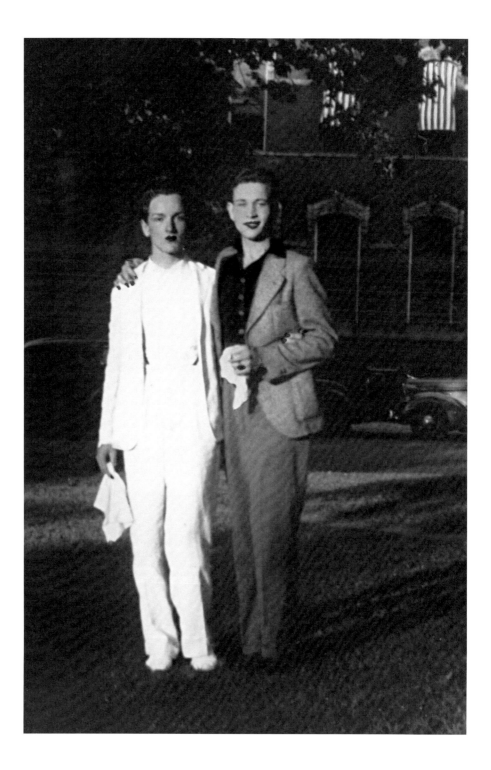

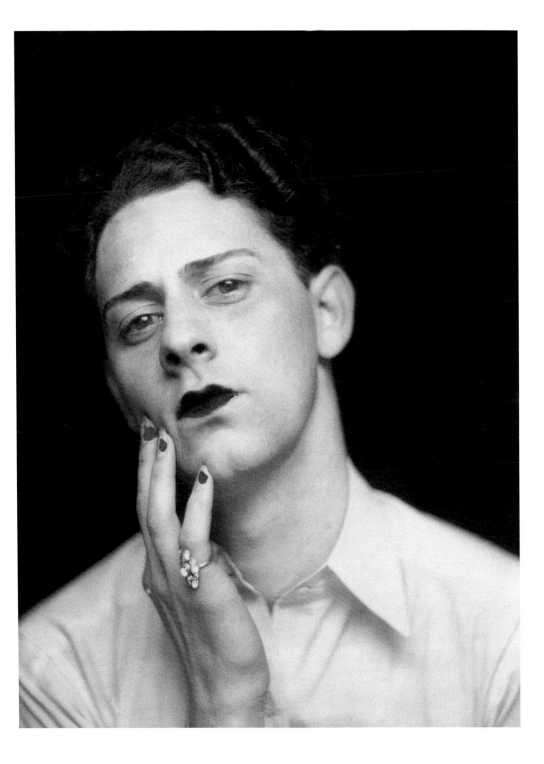

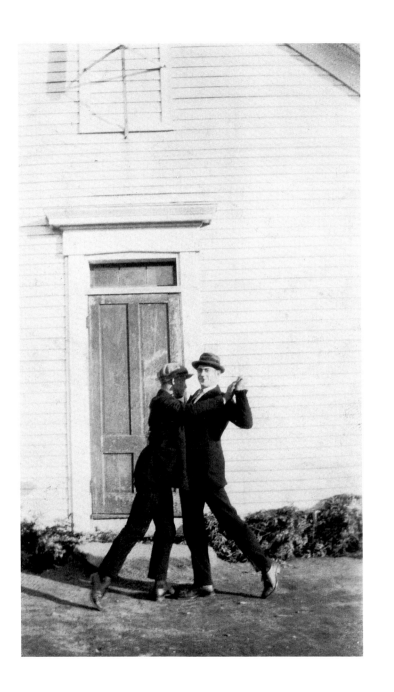

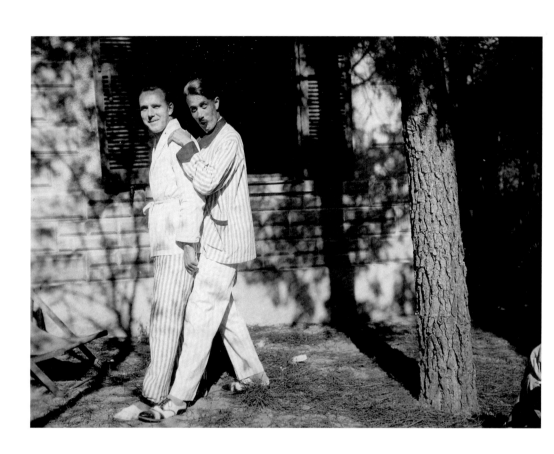

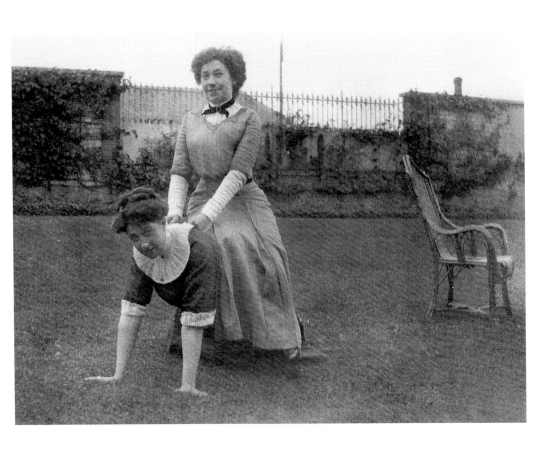

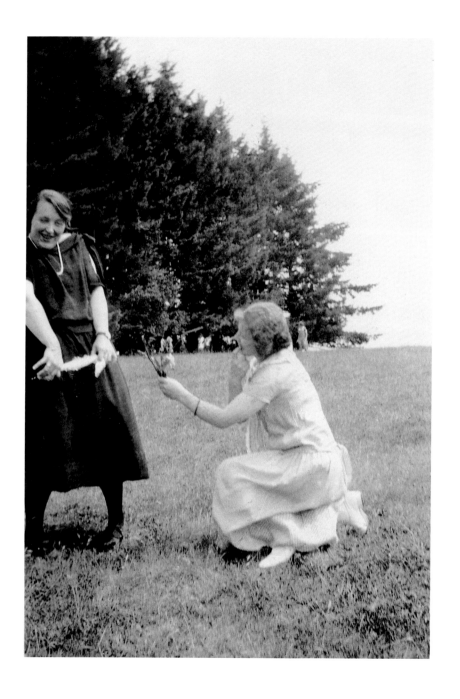

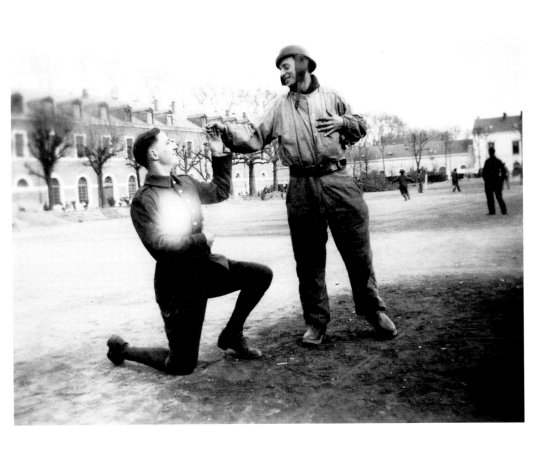

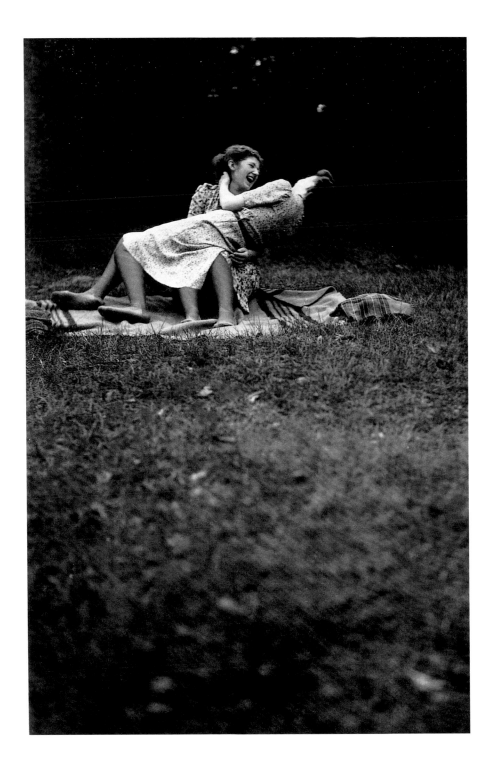

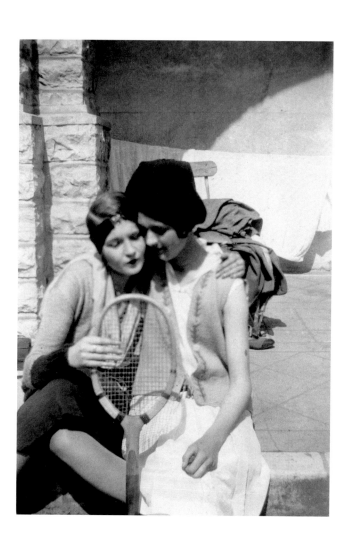

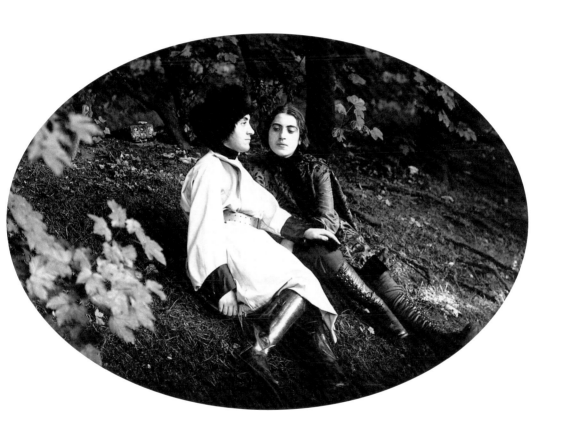

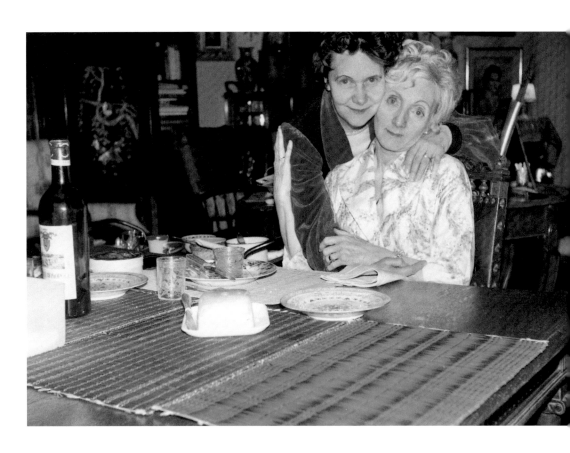

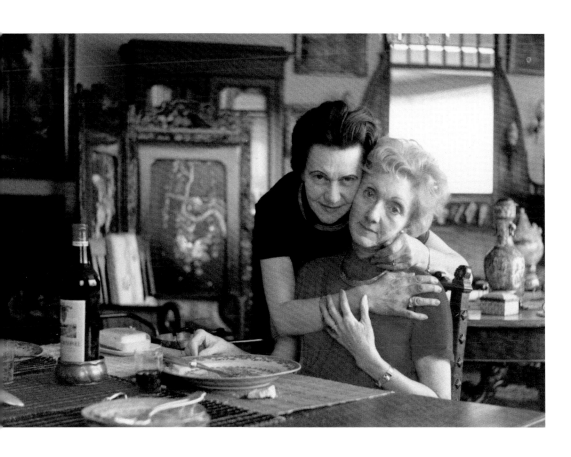

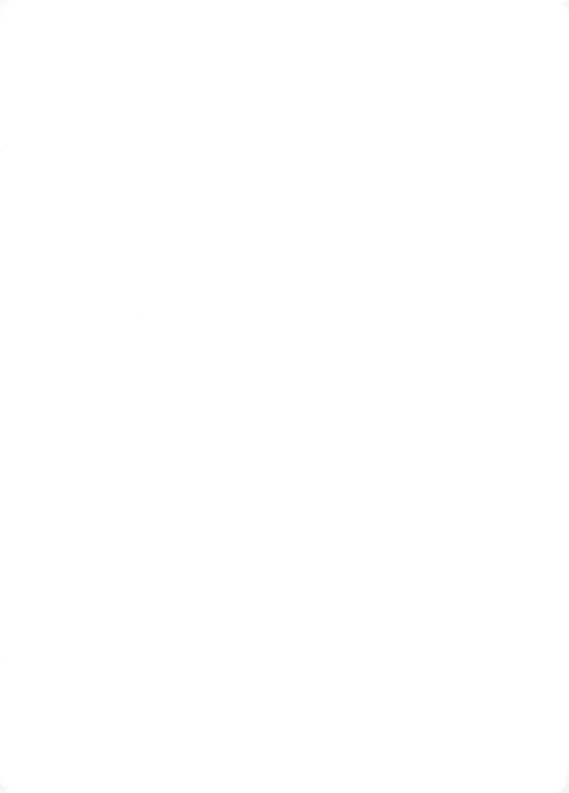

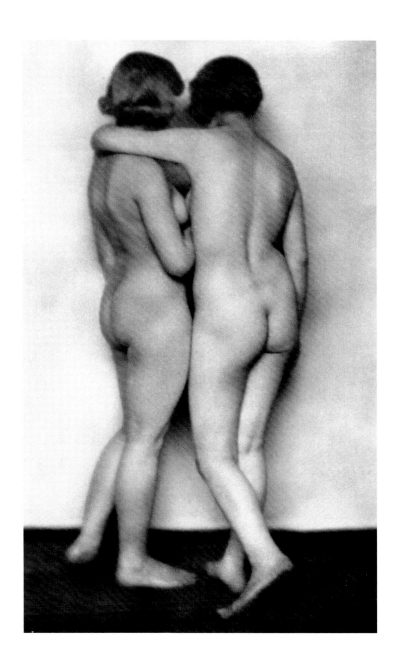

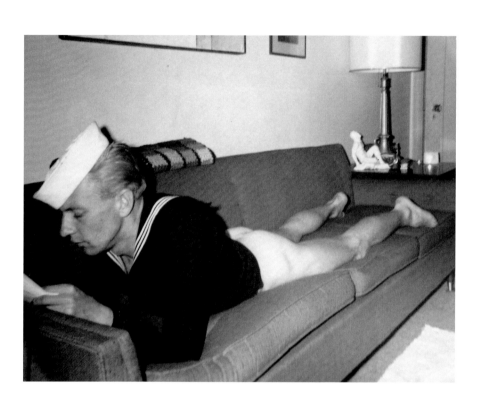

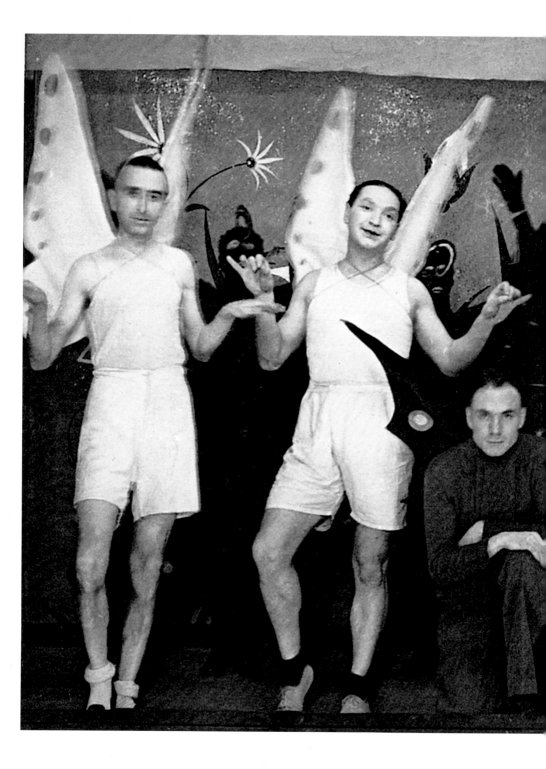

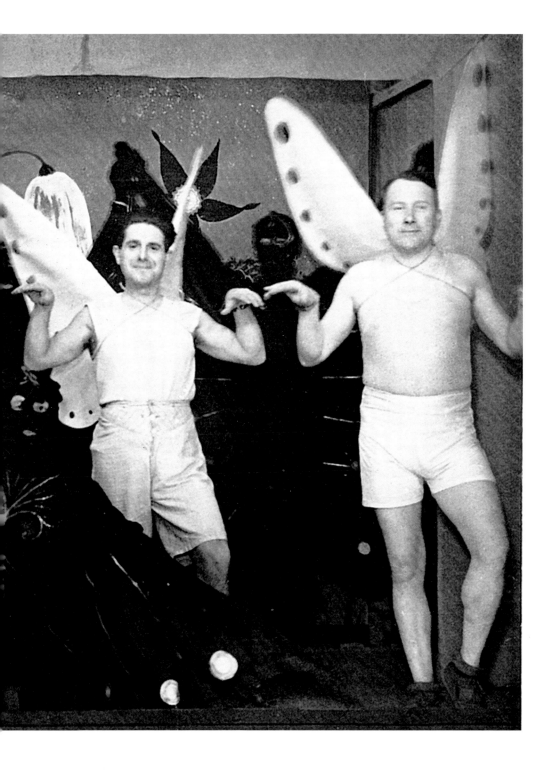

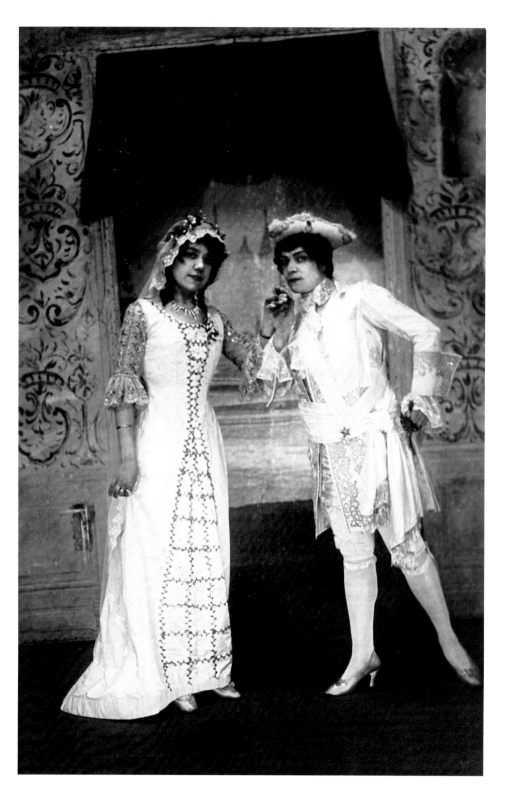

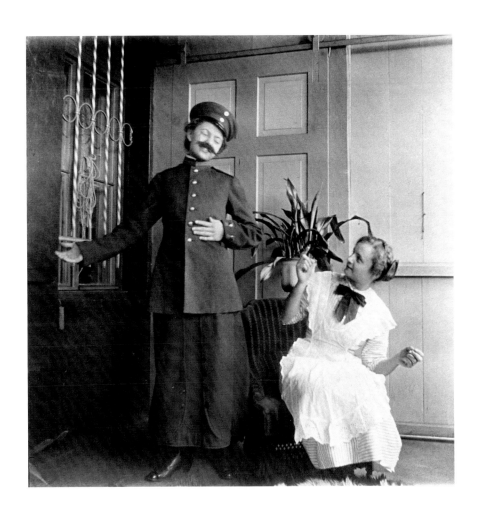

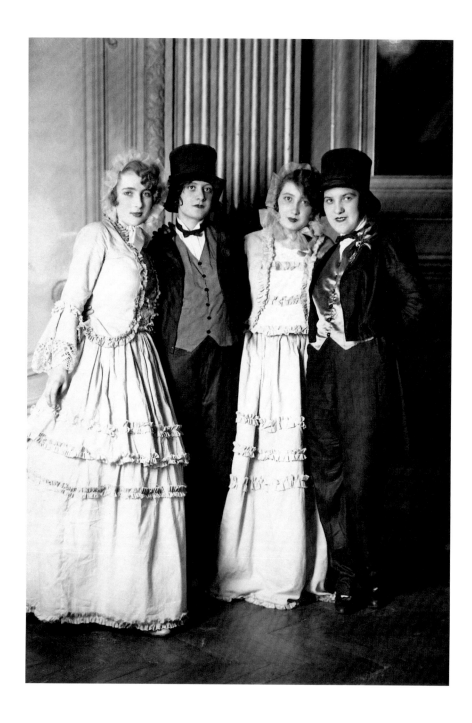

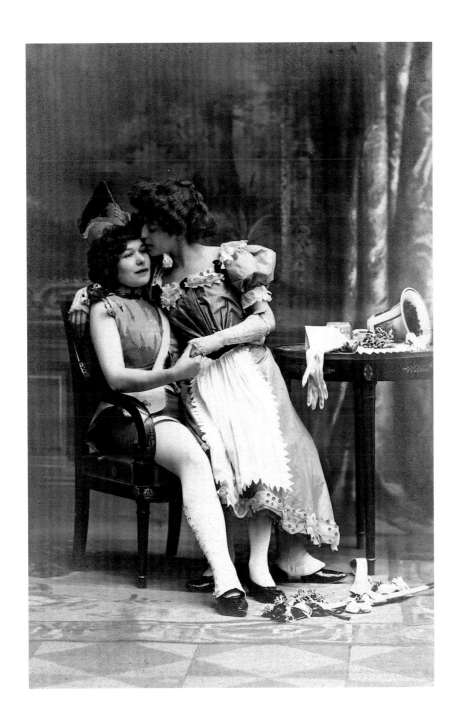

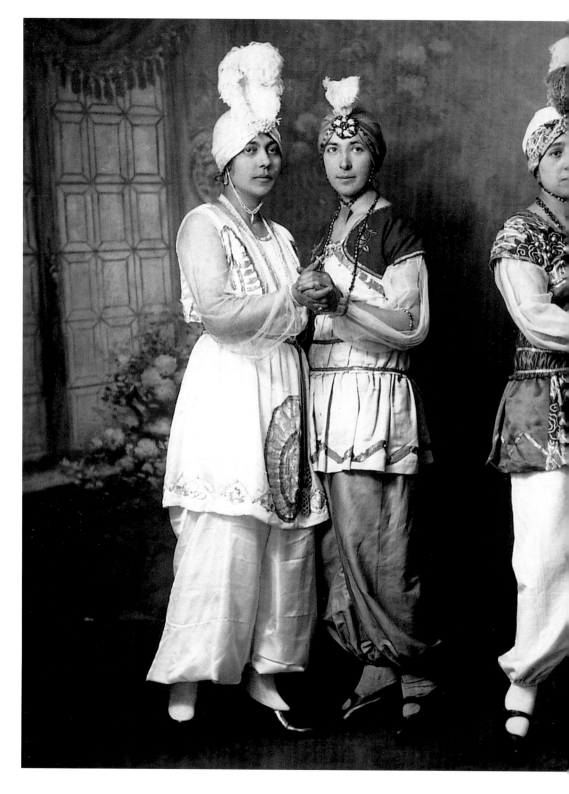

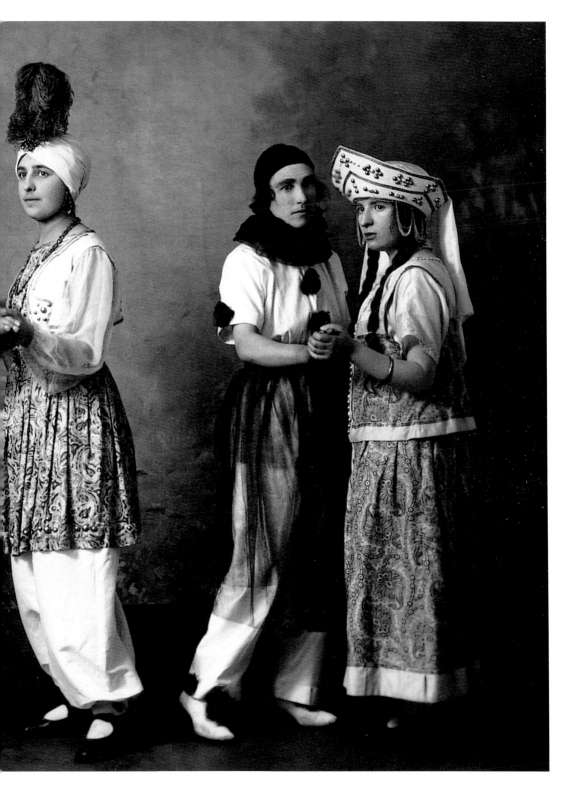

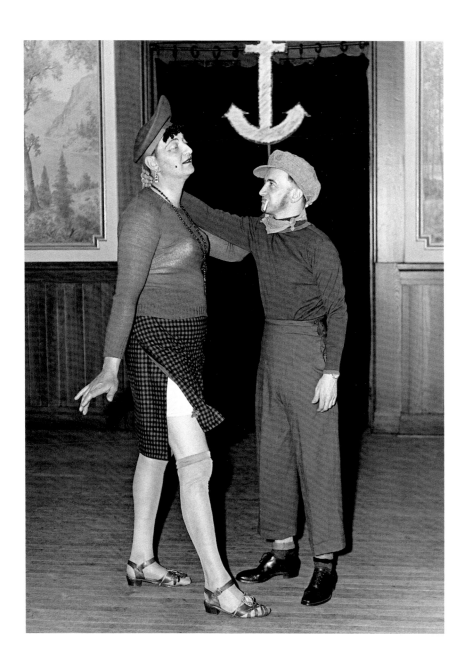

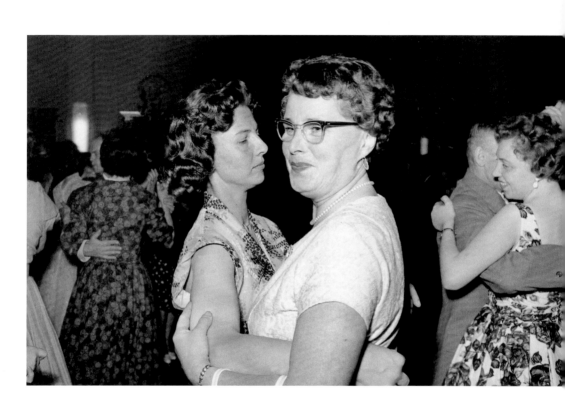

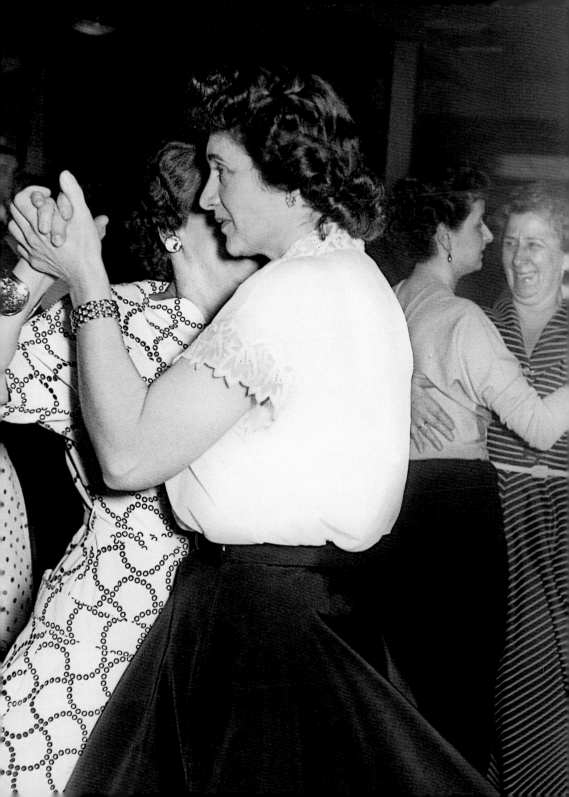

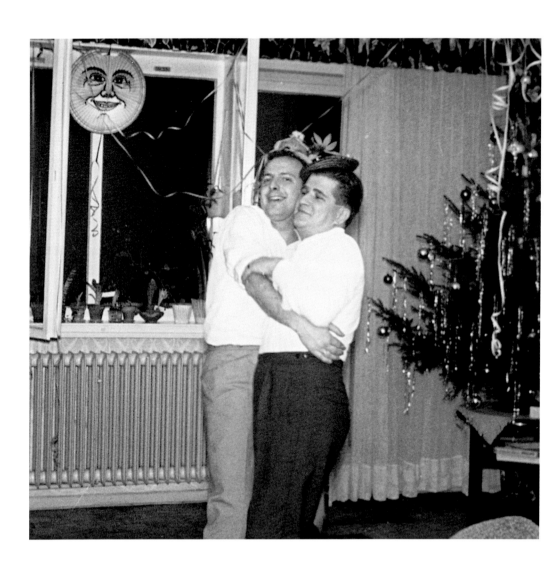

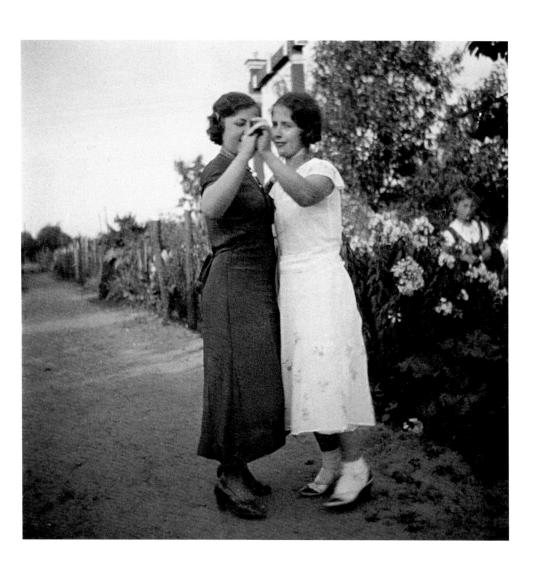

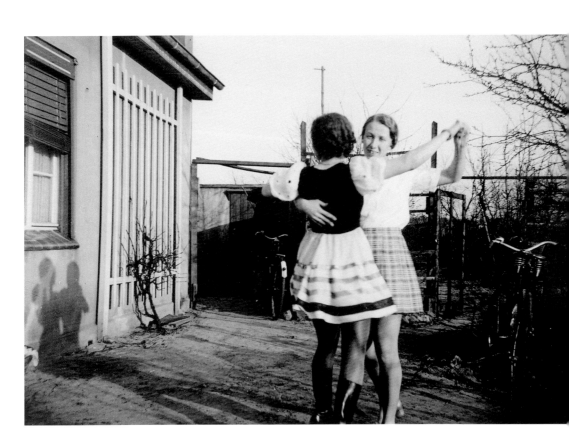

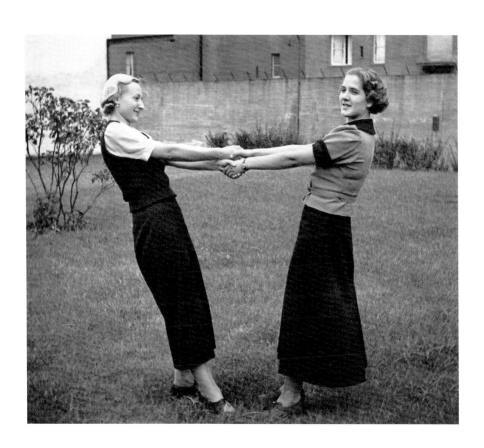

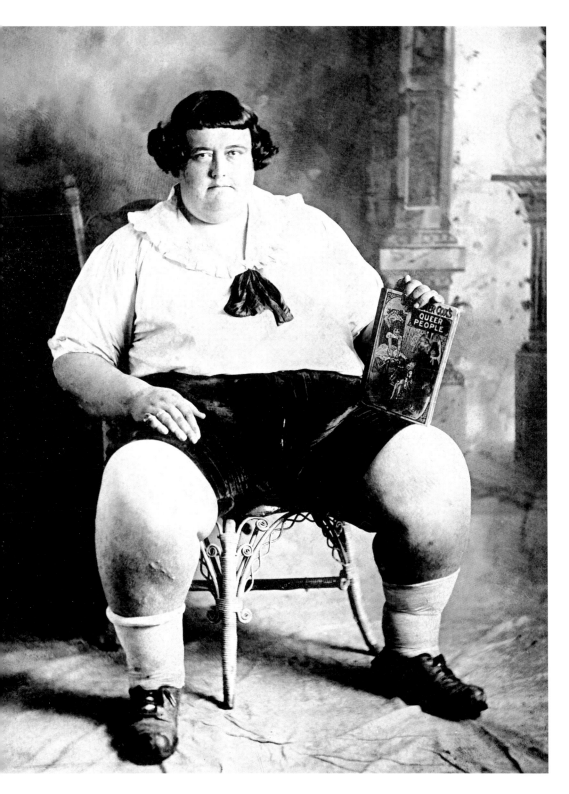

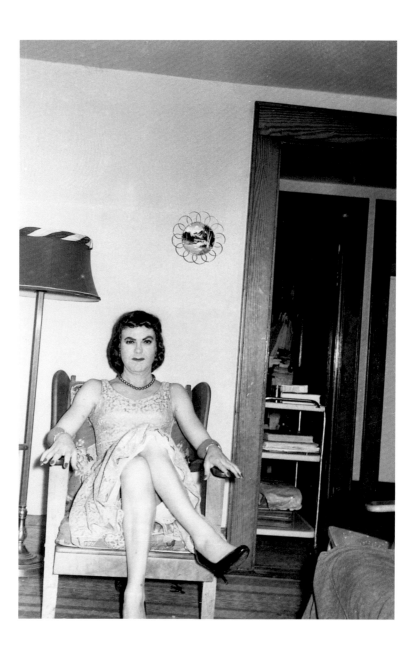

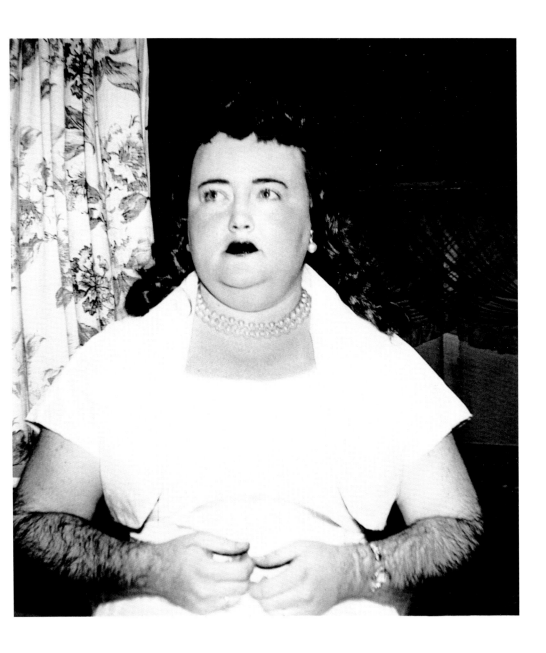

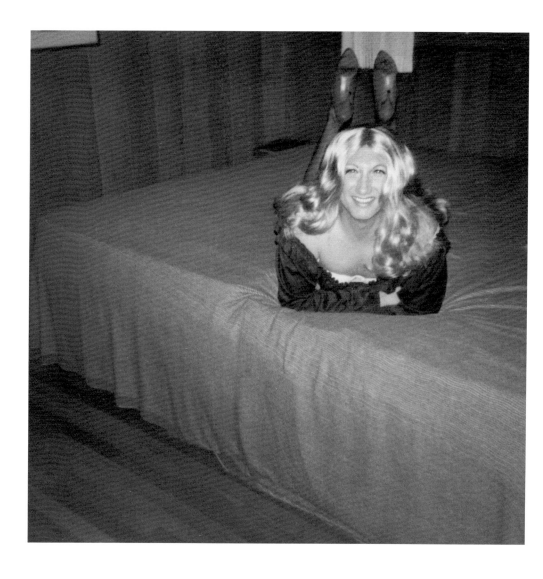

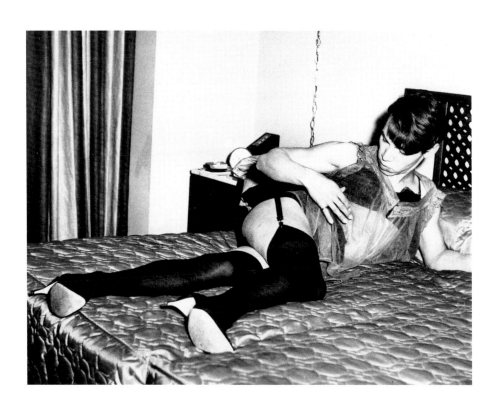

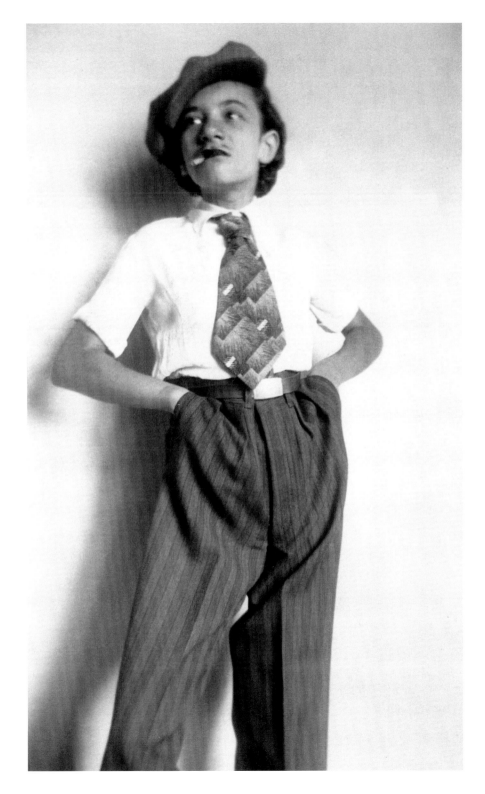

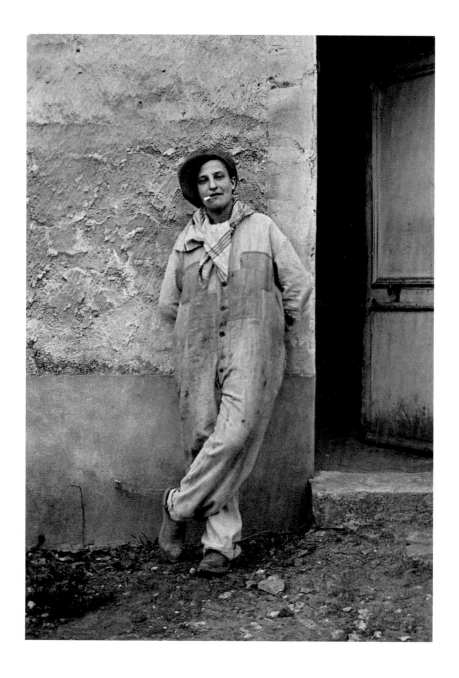

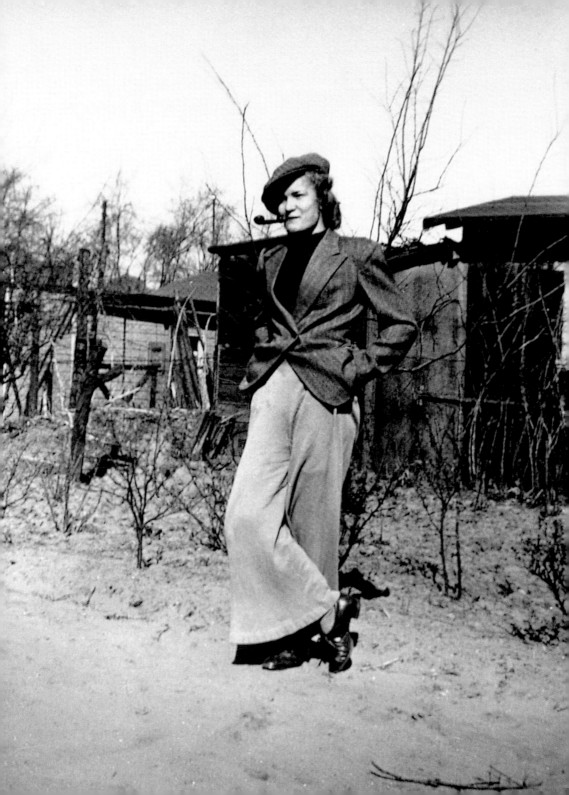

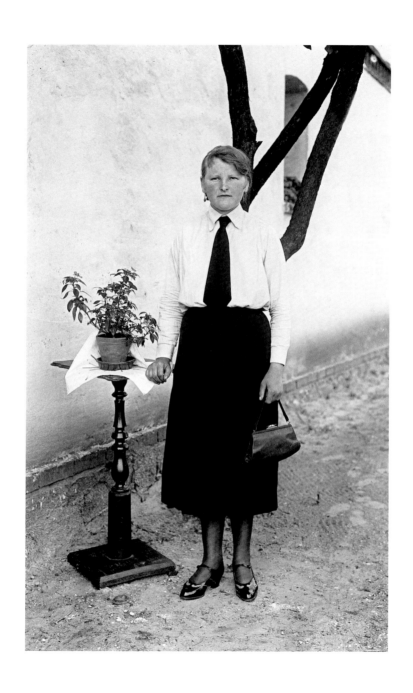

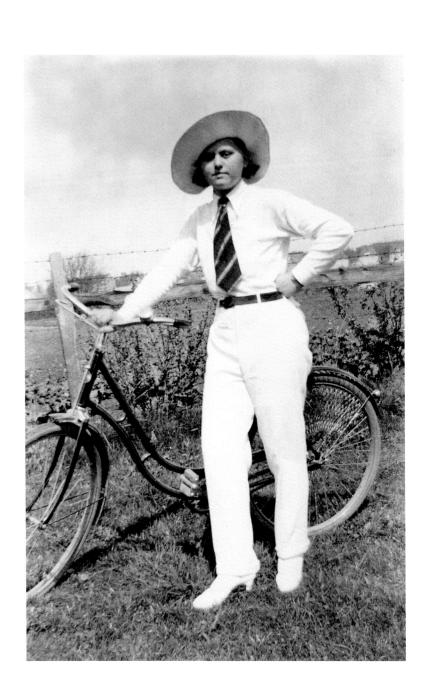

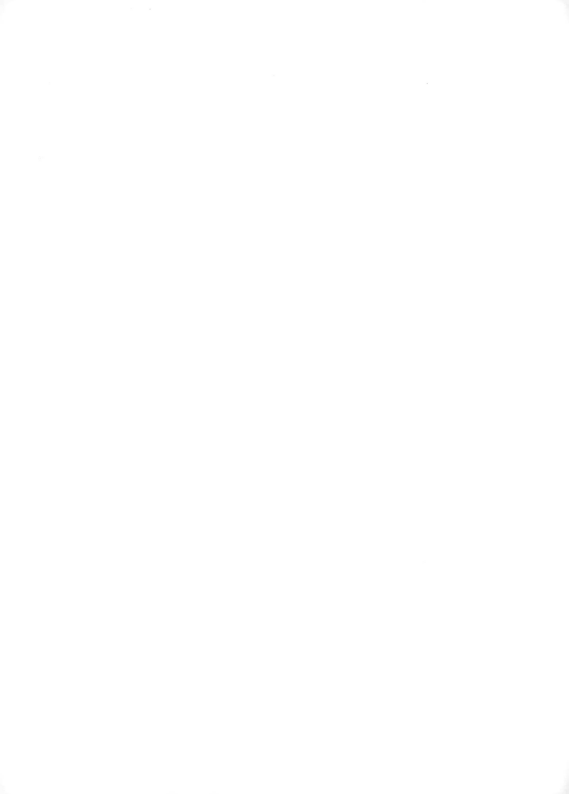

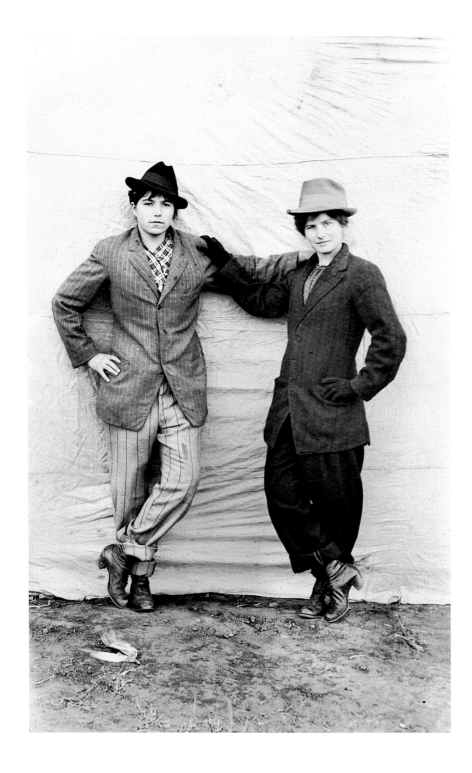

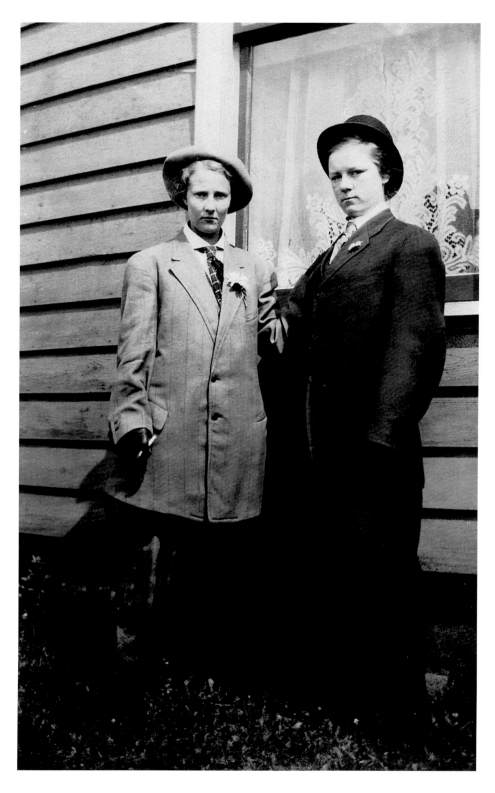

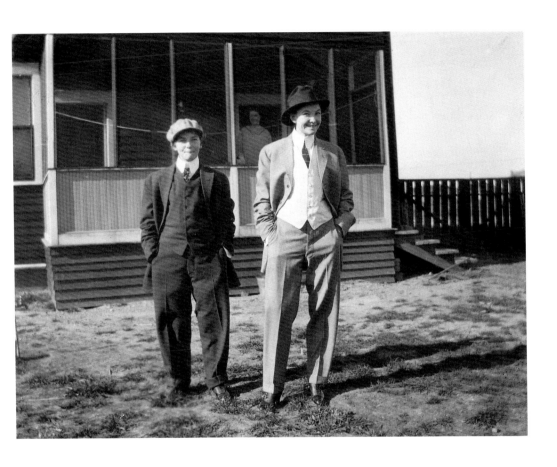

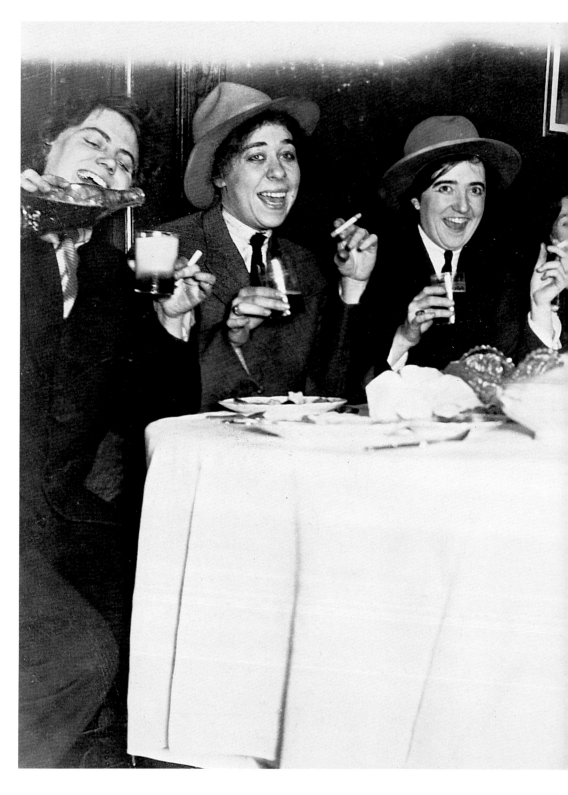

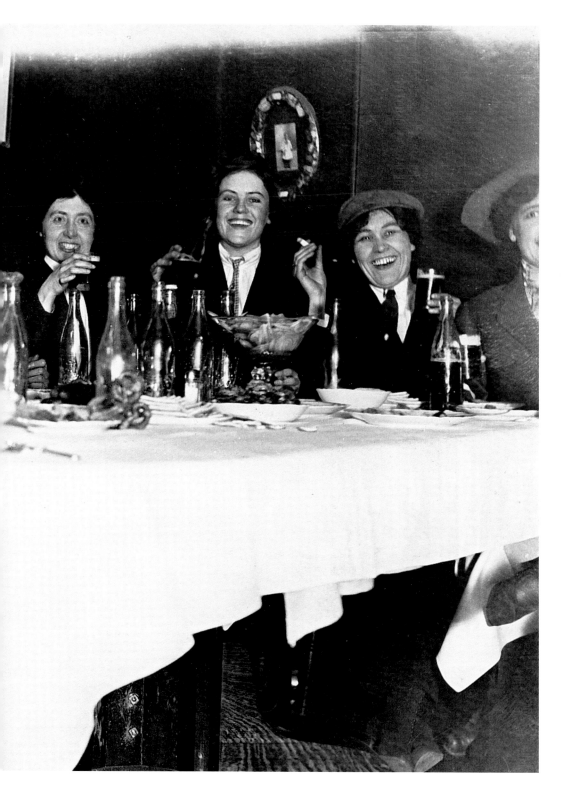

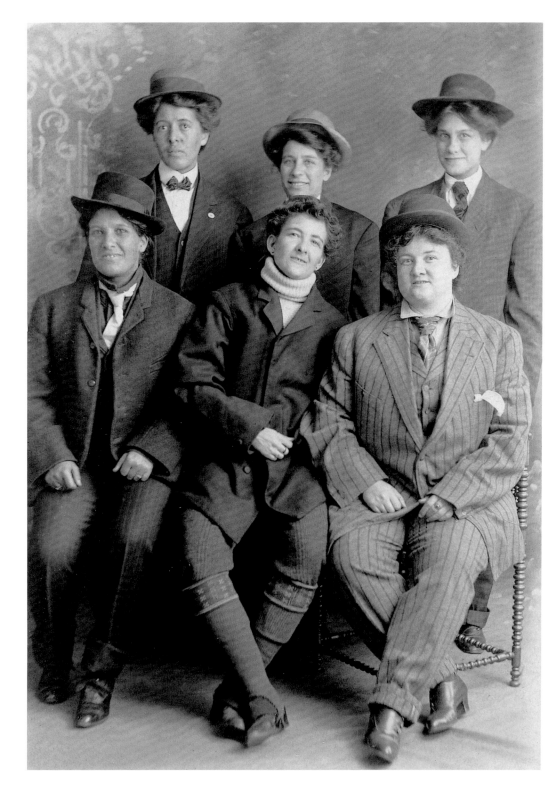

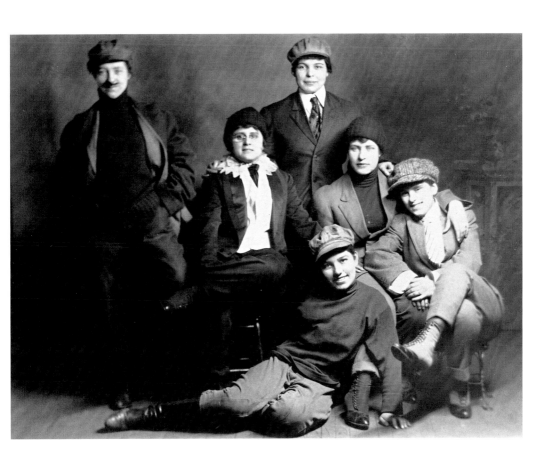

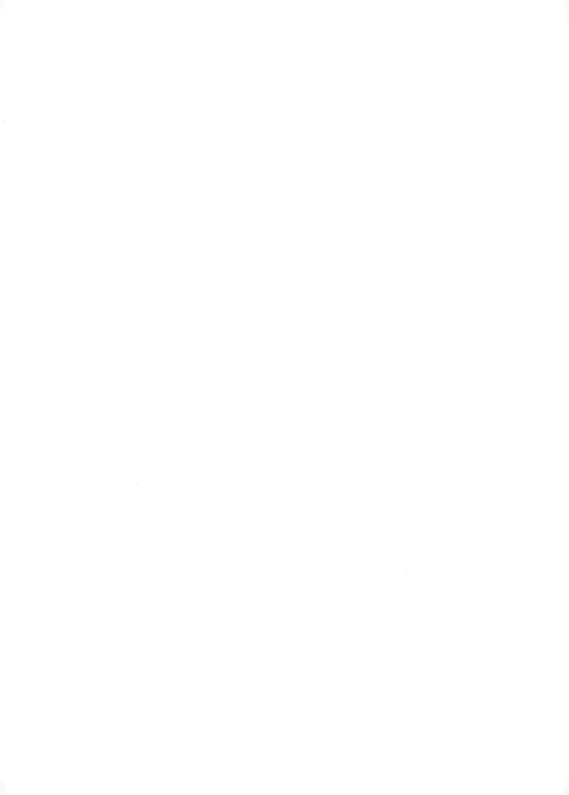

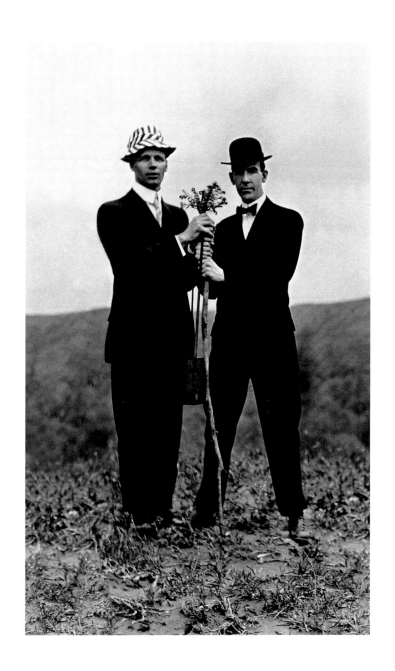

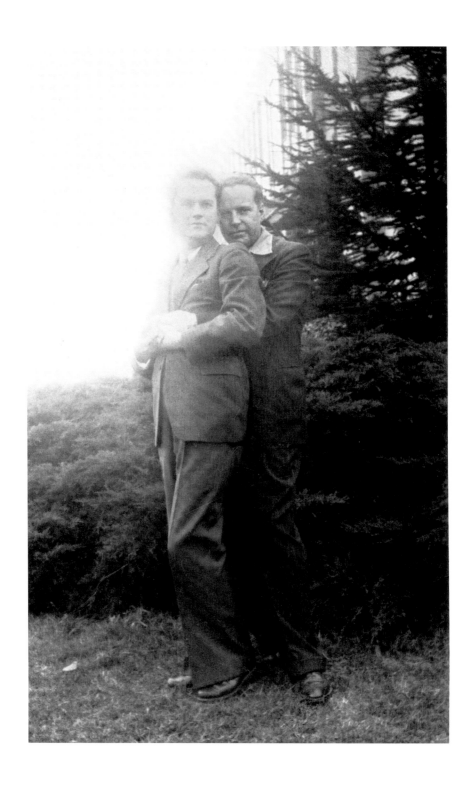

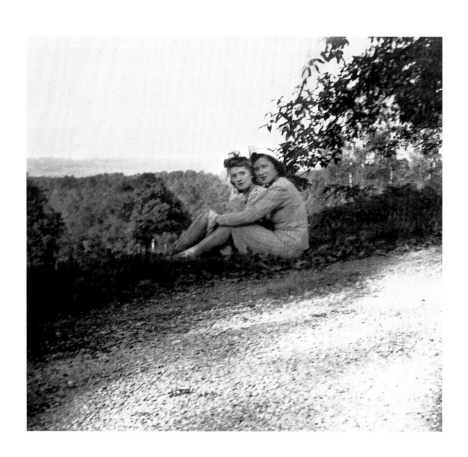

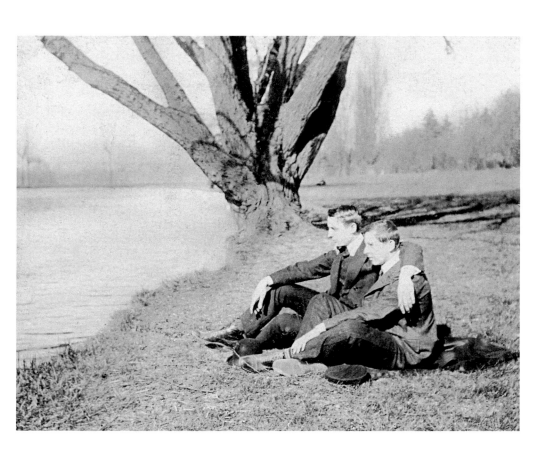

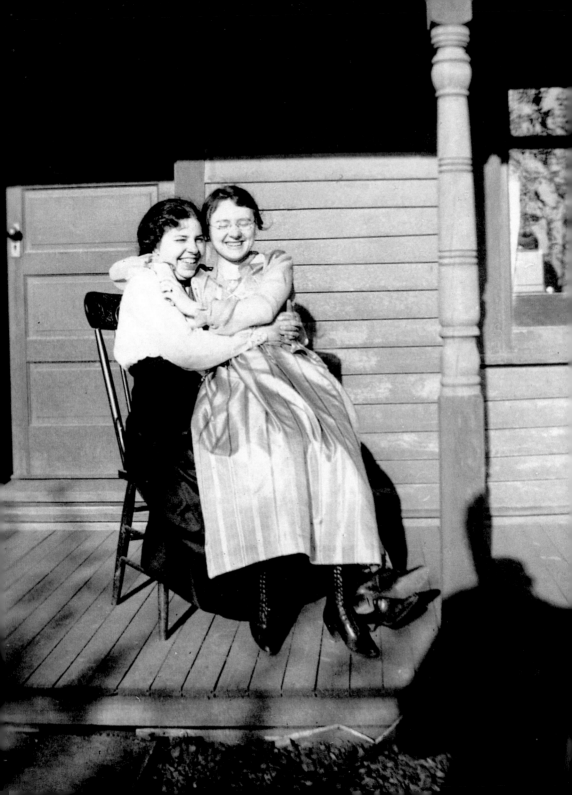

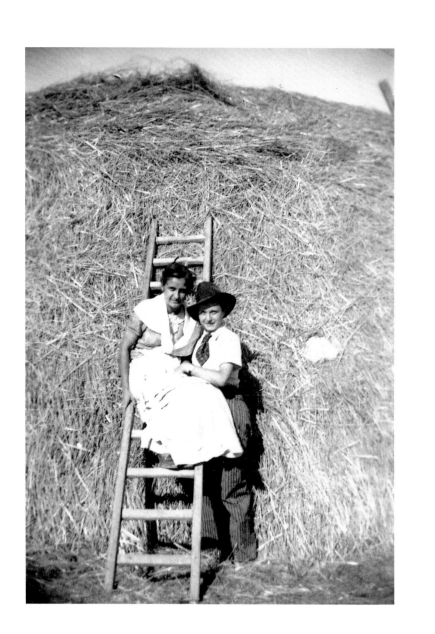

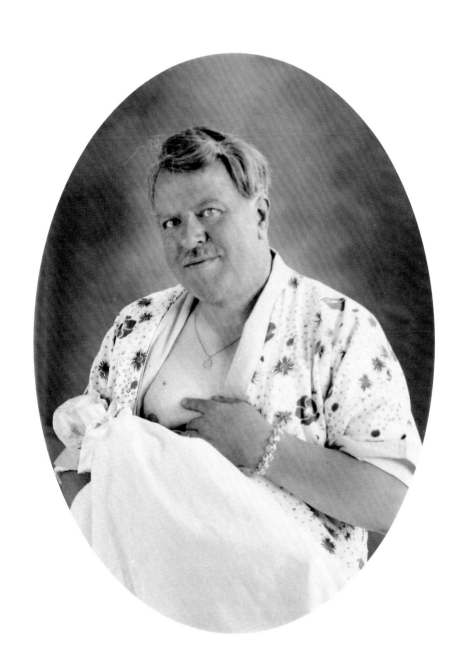

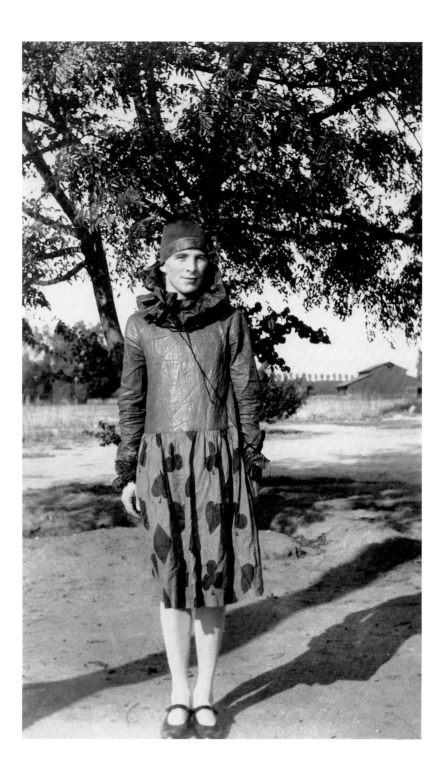

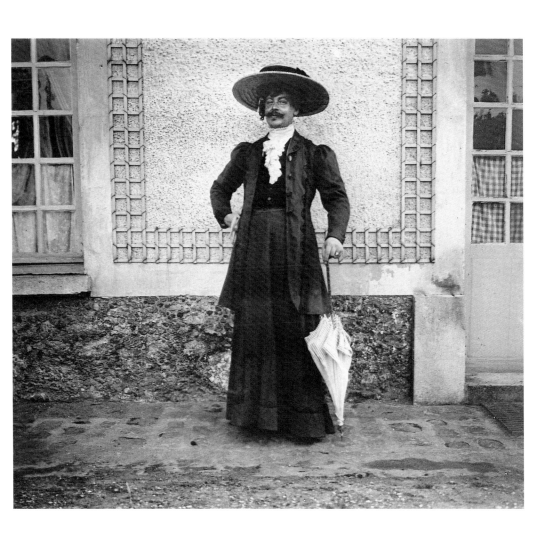

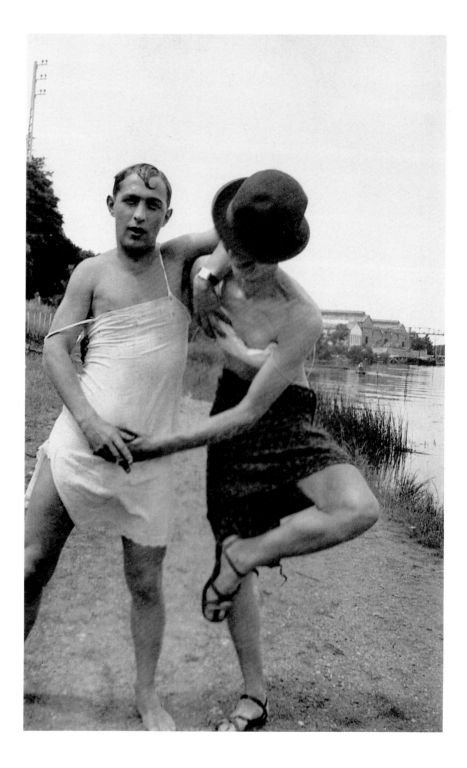

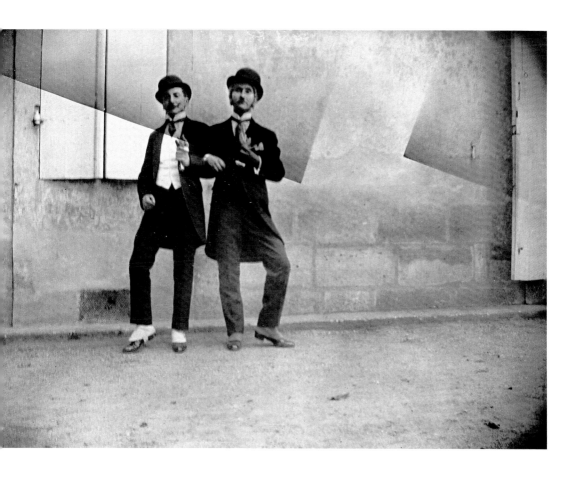

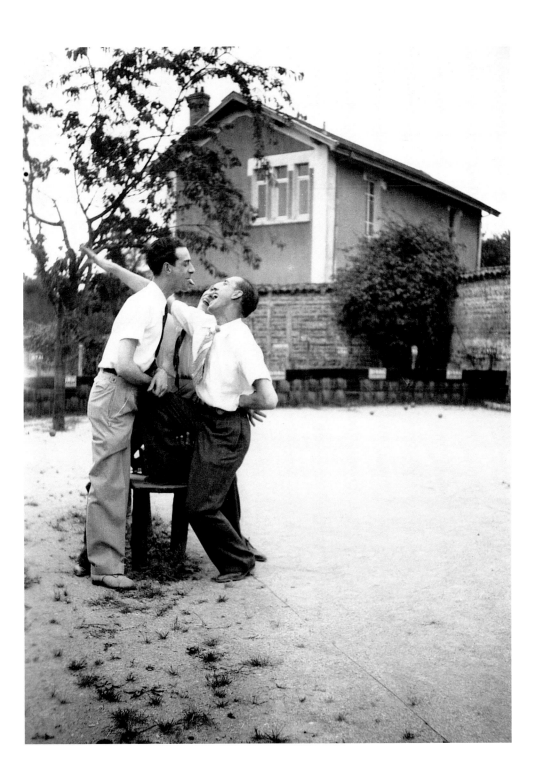

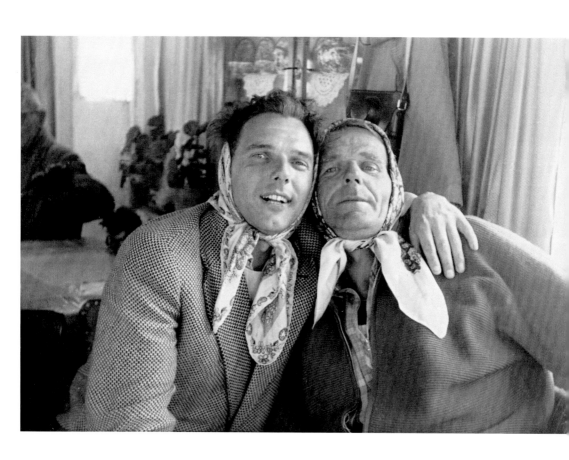

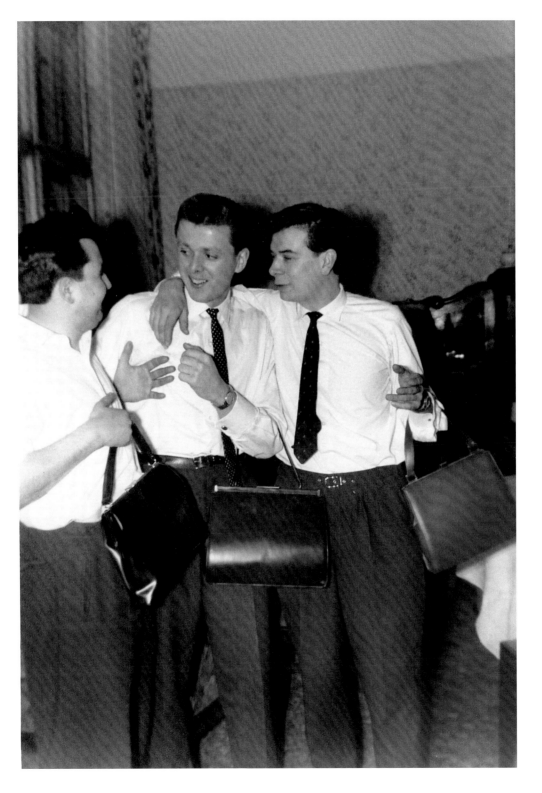

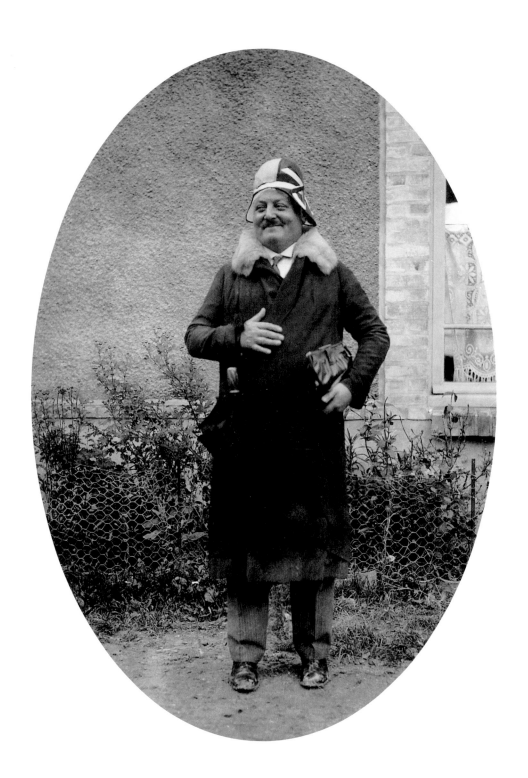

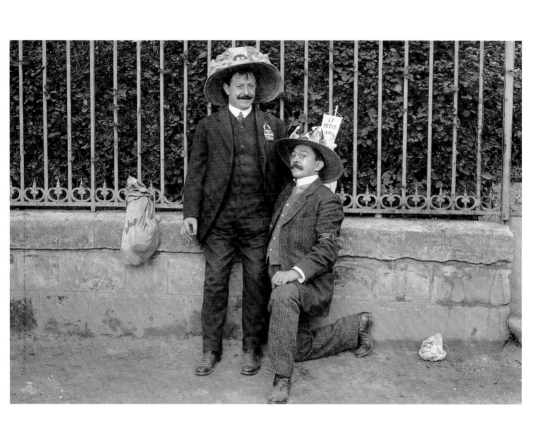

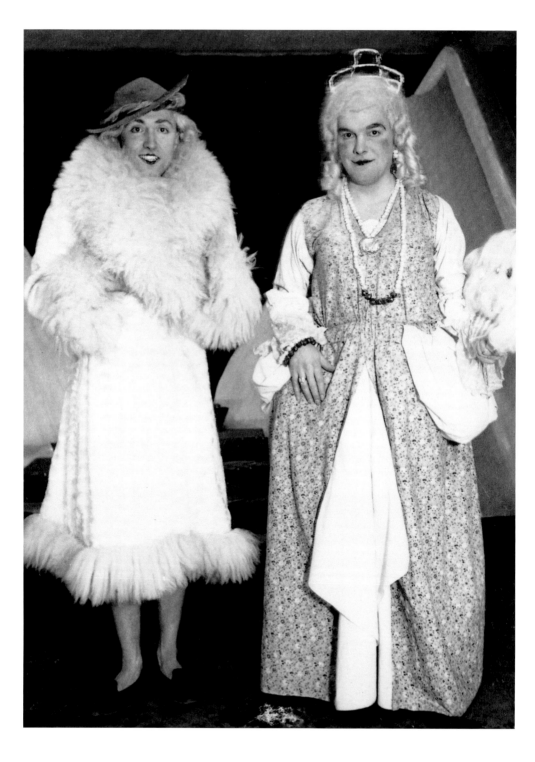

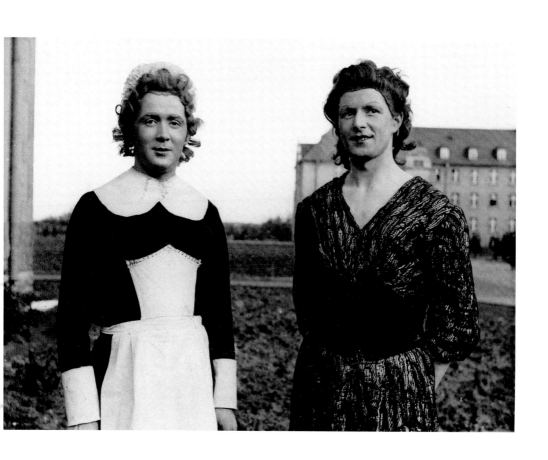

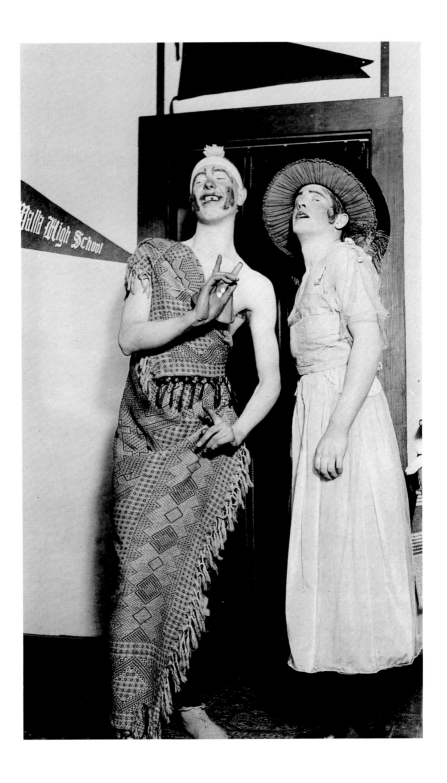

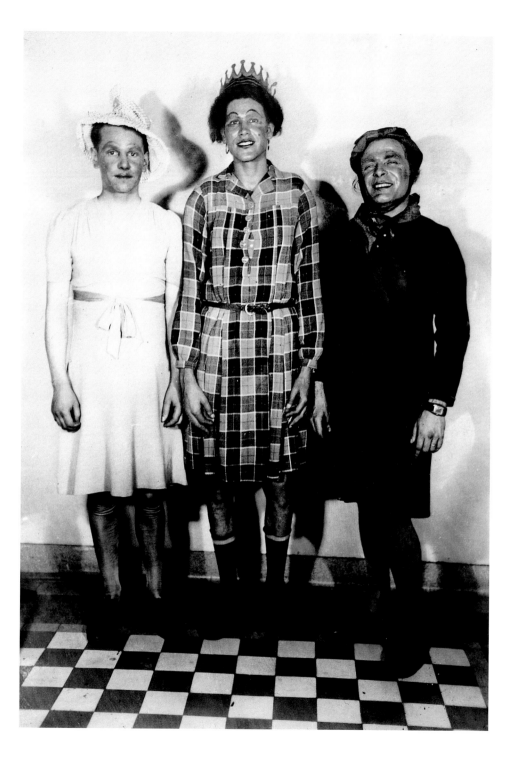

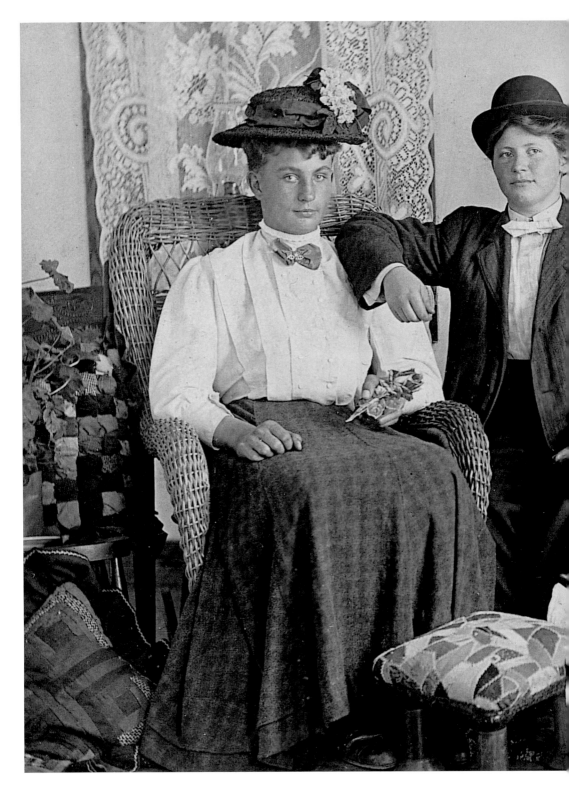

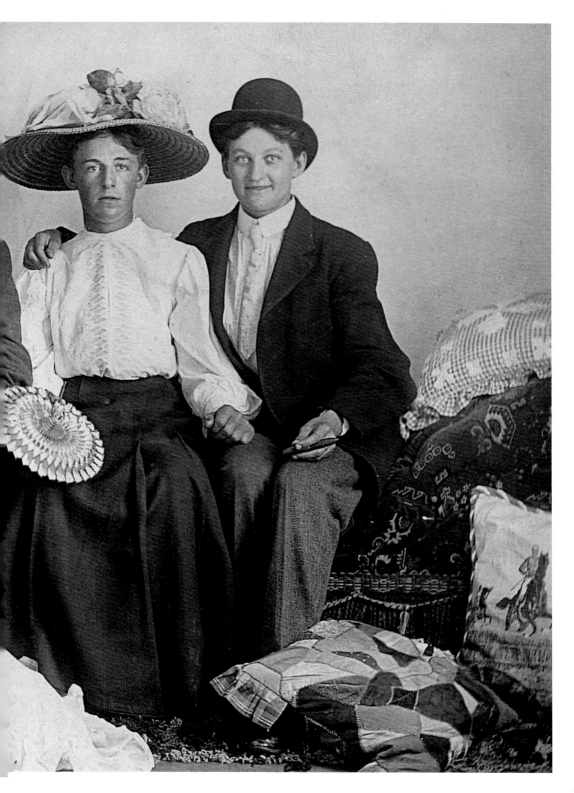

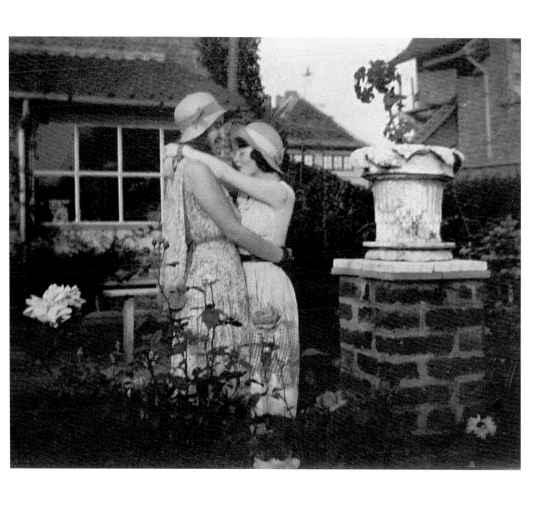

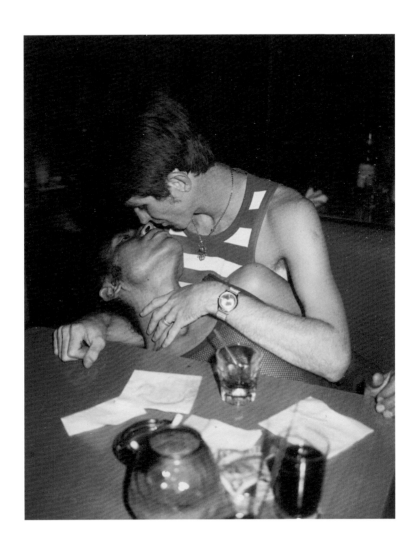

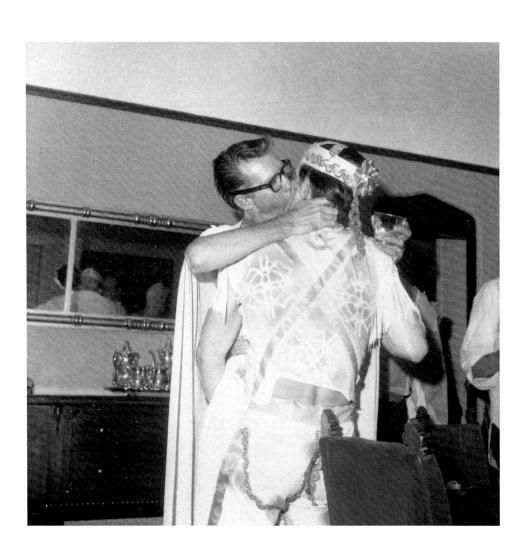

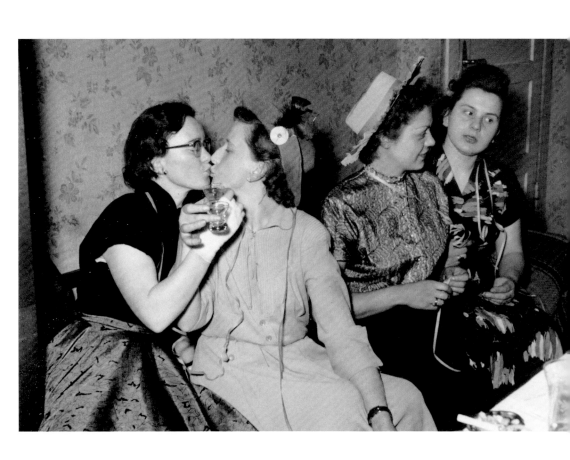

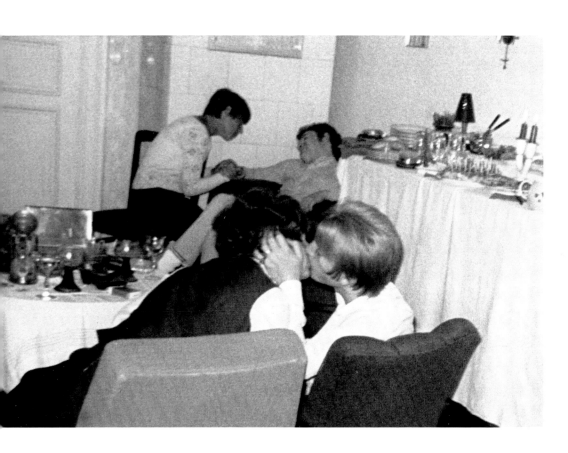

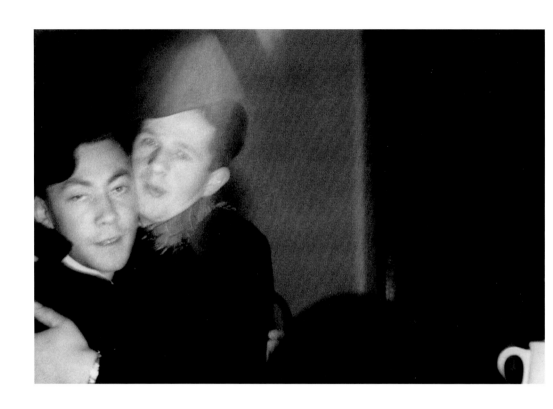

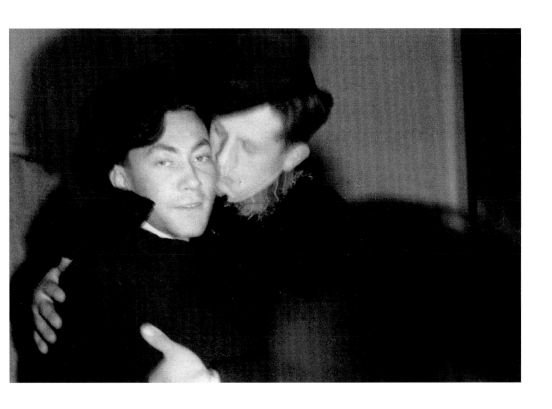

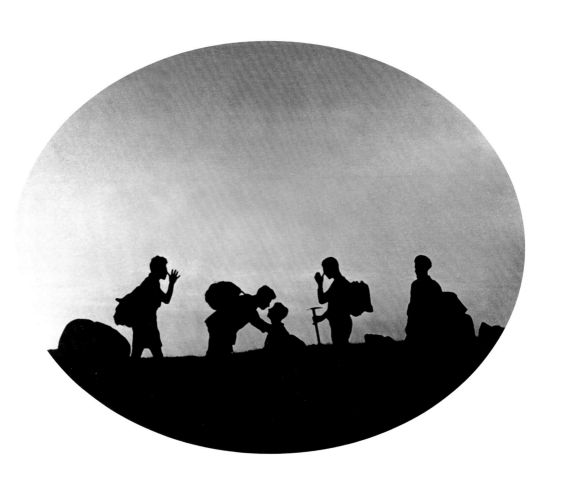

I would like to thank all the merchants where I have found veritable little treasures from time to time. I am thinking in particular of flea market dealers all over the world, as well as of tremendous photographers and collectors of amateur photography, like Barbara Levine, Fabien Breuvart, Serge Plantureux, Philippe Jacquier, Emmanuelle Fructus, Mark Sullo, and Stacy Waldman. I would like to make a special dedication to Céline Duval for her keen eye for the images.

I also wish to thank Bruno Nahon, Eugénie Michel, Mathilde Raczymow, Philippe Thiollier, Pascal Guerin, Antoine Parouty, Pauline Gaillard, and Tina Baz for having worked with such generosity on the adventure of *The Invisibles*.